Best of Friends 4

The yearbook of Creative Monochrome

Editor

Roger Maile

CREATIVE
MONOCHROME

BEST OF FRIENDS 4
The yearbook of Creative Monochrome
Editor: ROGER MAILE

Published in the UK by Creative Monochrome Ltd
20 St Peters Road, Croydon, Surrey, CR0 1HD.

British Library Cataloguing-in-Publication Data:
A catalogue record for this book is available from the British Library.

ISBN 1 873319 31 2
First edition, 1997

ISSN 1359-446X

Printed in England by Saunders & Williams Ltd, Belmont House, Station Road, Belmont, Sutton, Surrey, SM2 6BS.

Introduction

Roger Maile

Photography means so many different things to so many different people. It can be simply a release from life's pressures, or a potent means of self-expression or self-discovery, a form of socio-political statement, a means of documenting our existence, a celebration of the beauty of the natural world, human form or manufactured objects, or a way of making a living. These are not, of course, mutually exclusive and I am sure that many readers would be able to add further examples to the list.

For whichever combination of these reasons, photography provides added purpose and fulfilment to the lives of many thousands of individuals around the world. And this is usually enhanced by the work being seen and appreciated by others. Getting photographs seen and appreciated, rather than hidden away and ignored, is very much the founding principle of Creative Monochrome. We have tried to promote this objective principally through publishing books and magazines, but also by promoting postal portfolios and regional groups, making people aware of exhibitions and workshops, and supporting both local camera clubs and independent groups.

The Friends of Creative Monochrome, with a membership now numbering over 6,000 people in more than 60 countries around the world, is the special interest group through which all these activities have been focused. And at the hub of Friends is this *Best of Friends* yearbook – the annual opportunity for all our Friends to submit work for inclusion in a book which will be seen by thousands of people. This year, 464 Friends submitted a total of 4,079 photographs, from which the 153 prints shown in this book were selected. Around two-thirds of the 111 photographers whose work is shown here have not been seen before in this series, and for many of these, this will be the first time their work has been published.

I have never seen *Best of Friends* as a yearbook in the sense of a review of the photographic year – it is simply an annual opportunity to showcase some of the previously unseen work by our members. However, two or three events during the past year have left impressions which I would like to take the opportunity to reflect upon here, albeit briefly.

The first, and most pleasing from a personal perspective, was our acquisition and re-launch of the magazine *Photo-Art International*. This greatly expands our ability to bring work to a wider audience, including the opportunity to reproduce colour work and to present more extended portfolios than is possible in *Best of Friends*. Although the magazine includes technique articles, news and reviews, every aspect of it is image-led. It should not be surprising or adventurous to publish an image-led photography magazine, but in the UK today it remains a novelty. To publish a photography magazine which is image-led, rather than dominated by equipment reviews, advertisements and '100 things to do with a Cokin filter'-type features, has been a long-cherished personal dream. To see this come to fruition and to receive such a wonderful response from the readership will keep a smile on my face even when they pack me off to the eternal darkroom.

The other two impressions are less favourable. I was disappointed this year to read a review of one of our books in which a photographic magazine publisher questioned the value of printing collections of photographs in book form – dismissing the exercise as

INTRODUCTION

simply an ego-trip for the photographer. This was a little surprising given that the same editor had previously waxed lyrical about other similar monographs we had produced (although we were not then publishing a rival magazine!).

There is a sense in which the publication of any art form – whether poetry, novel, music, movie or painting – is an ego-trip for the artists involved: self-expression is necessarily a personal indulgence. But without such indulgence we would be deprived of the spiritual uplift, entertainment and inspiration which all such art forms offer us. Whether these art forms generate such a response is as much to do with the sensitivity and receptiveness of the receiver as with the ego of the giver.

Sensitivity is as delicate a flower as the ego: it too needs careful nurture and occasional pruning. The ability to tune-in to the wavelength of the artist does not always come easily: the cursory dismissal of a piece of work requires less effort than trying to understand it. Through Creative Monochrome, we have always tried to encourage a broad appreciation of different styles and subject matter in photography. This does not, of course, mean that we expect everyone to derive the same level of enjoyment from every image we publish: some photographs will inevitably have a more ready and lasting appeal for individual viewers than others.

We are not always successful in preaching our 'broad church' philosophy. I remember one Friend writing to me about a particular book which I hold in great affection, giving his opinion that the images were repetitive and that we had obviously included many to "pad the book out". I could imagine the reader turning the pages, saying to himself: "Here's a picture of a tree; here's another picture of a tree; blow me, here's yet another picture of a tree" and then closing the book in disgust. I wonder if he went into his garden for solace only to be dismayed by the repetition of flowers, plants and birds which he found there, or went to the pub and found a repetition of human beings awaiting him. I am in no position to mock, because I have a similar reaction to mechanical objects, like cars and trains – I recognise the most obvious superficial differences, but find it difficult to imbue them with character or a significance beyond their obvious value as a means of getting from 'a' to 'b'.

Like the disgruntled book reader, some pictures leave me cold. I do make an effort to appreciate them, but ultimately am left wondering why the photographer made them. This does not necessarily mean they are 'bad' photographs, it just means that I cannot relate to them. Whether this is a weakness on my part or that of the photographer is open to conjecture.

I hope readers will find a pleasing variety of styles and subject matter in this book. Far from being padded out, it was desperately difficult to whittle the prints down to the number which it is possible to include. I am equally sure that there will be some images which do not 'work' for some readers, but I hope they will make the effort to appreciate them and gain some idea both of why they were selected and what the photographer was seeking to achieve. One of the most pleasing things to find when editing the contributor profiles at the back of the book was that so many photographers had referred to Creative

INTRODUCTION

Monochrome as one of the motivating factors in their work: one photographer even wrote that it was the gift of a copy of *Best of Friends 3* which inspired him to return to monochrome photography after many years' absence – a year later, maybe the inclusion of his work will have the same effect on others.

The third impression of the year was a cheap and unsubstantiated comment by Angela Hopkinson in the introduction to a book by Grace Lau, where Ms Hopkinson referred to the "fact" that "hundreds of amateur camera clubs across the country specialise in offering the male voyeur a forum for his crudest fantasies".

I travel the country presenting talks to and judging competitions at camera clubs. Such clubs are often the butt of snide comments – usually for the competition mentality rather than as dens of pornography. And yet you only need to read the profiles in the back of this book to see how important clubs are in fostering the enjoyment of photography and in sharing knowledge of the technical skills involved. At a time when they are generally having trouble in maintaining membership and attracting and retaining the interest of young photographers, ill-informed comments are something they could well do without.

Let me deal briefly with the 'competition mentality' point (as Ms Hopkinson's crude jibe is not worthy of reply). It is true that the club competition is the cornerstone of many club programmes. Although disagreeing, I do have some sympathy with those who regard the idea of any form of competition in the arts as tantamount to obscenity. And, indeed, if winning competitions became the only motivating factor for a photographer, then I would feel sorry for him or her.

But for most club photographers, the competition evening is prized as an opportunity to have their work seen and to receive feedback. Most wisely disregard the witterings of judges like myself, but value the comments and appreciation of fellow members. For less experienced workers, it is an opportunity to see at firsthand the potential of the medium as demonstrated by the work of other members. Viewed in this perspective, the idea that clubs and judges seek to impose outmoded and stultifying ideas about style, technique and composition should no longer be valid. Indeed, some clubs and most of the independent groups have already moved away from the idea of 'judgment day' towards group discussions, 'appreciations' and public exhibition.

True, the independent groups, workshop centres and colleges play an important part in fostering enthusiasm for photography and knowledge of its craft skills, but the local camera club remains central to the propagation of this wonderful and fulfilling medium, and I hope that those involved in the industry will continue to offer them the support and encouragement they richly deserve.

I hope that the selection in this edition of *Best of Friends* will, like the camera clubs, provide the same opportunity for Friends to appreciate the possibilities of the medium and to be inspired by what others have achieved. Enjoy!

Index of contributors

(The numbers in italics refer to the plate numbers in the book (not the page) of the photographers' images.)

Portfolio

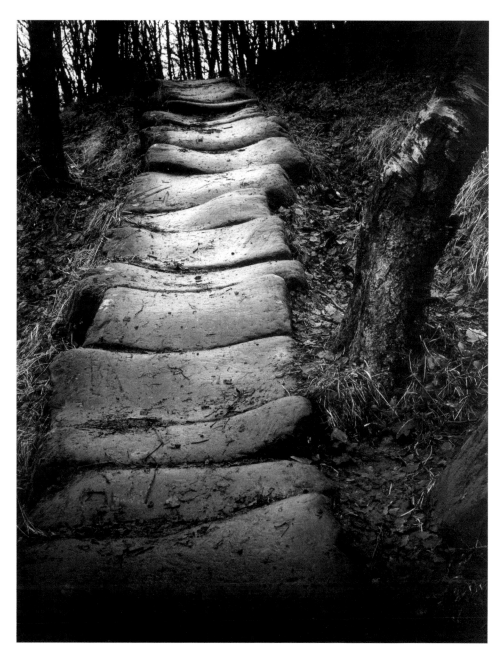

1
Monks Trod
Donald Nesham

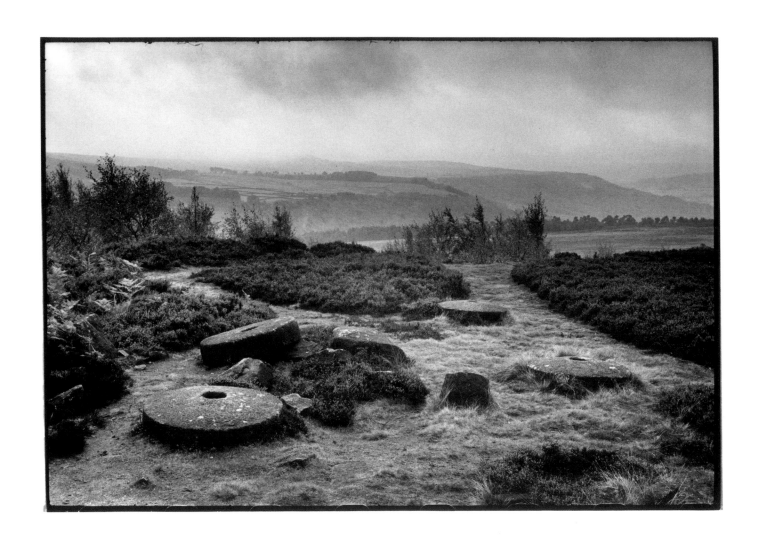

2
Millstone view
Paul Damen

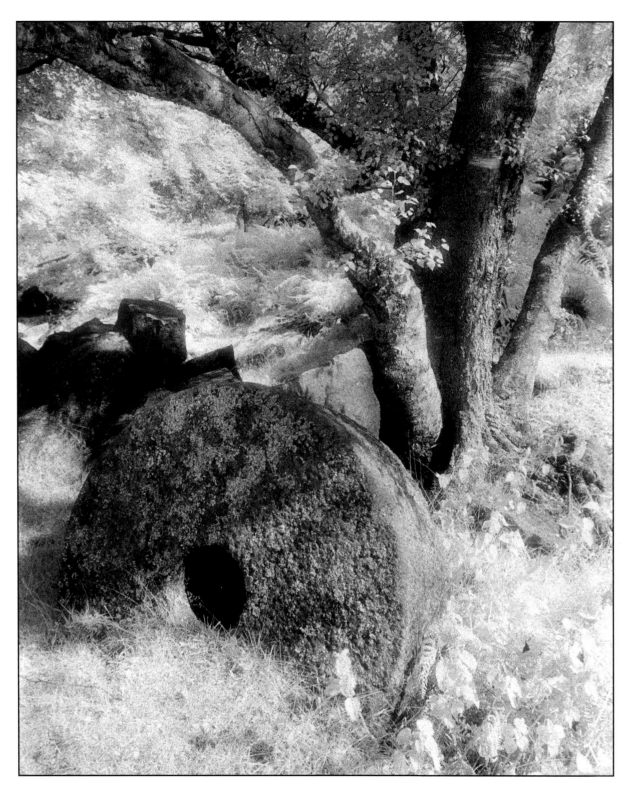

3
Millstone and silver birch
Roy Penhallurick

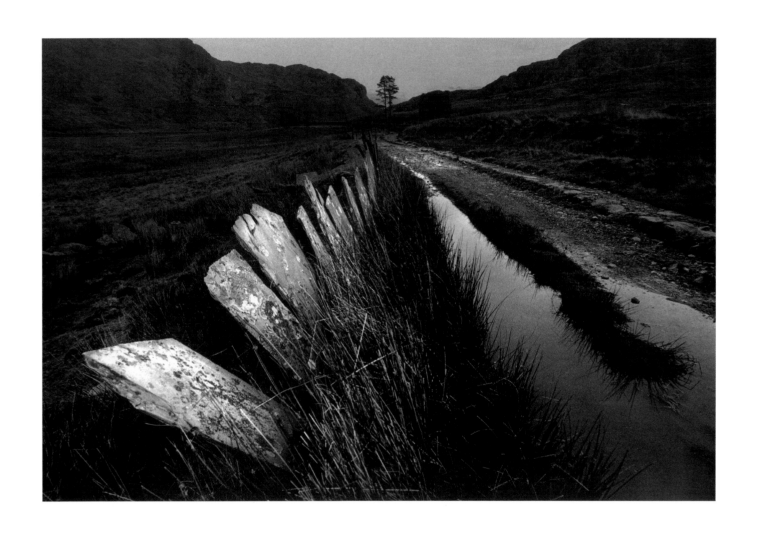

4
Welsh slate
Alfred Hoole

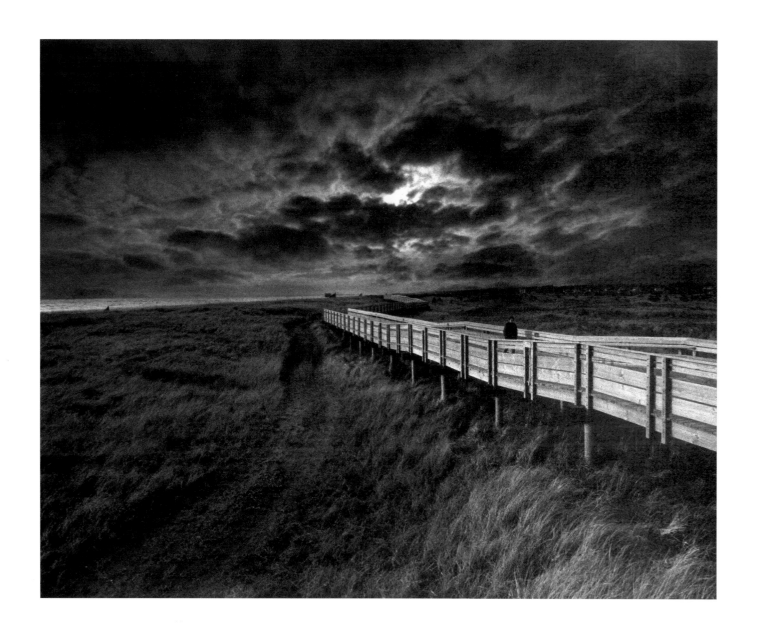

5
Going home
Tan Boon Kiat

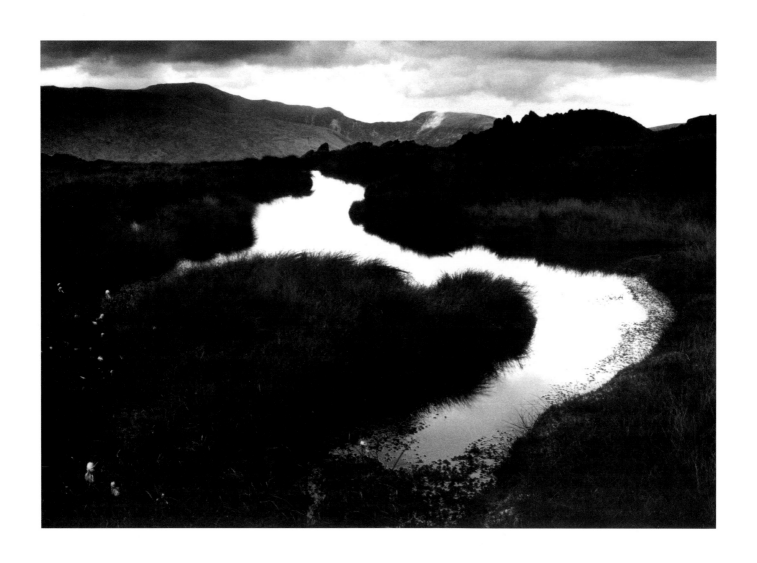

6
Llyn y Caseg Traith
Paul Webster

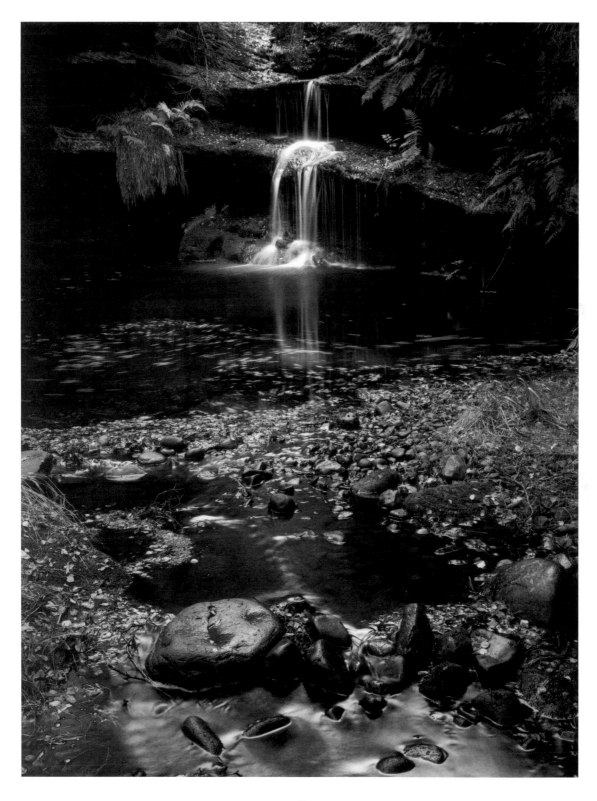

7
Secret falls
Paul Damen

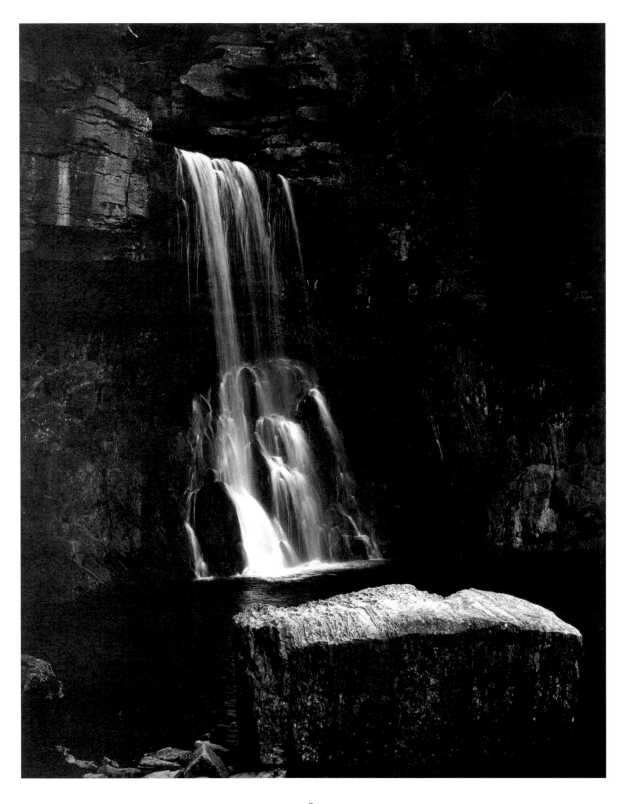

8
Ingleton Falls
Bill Hall

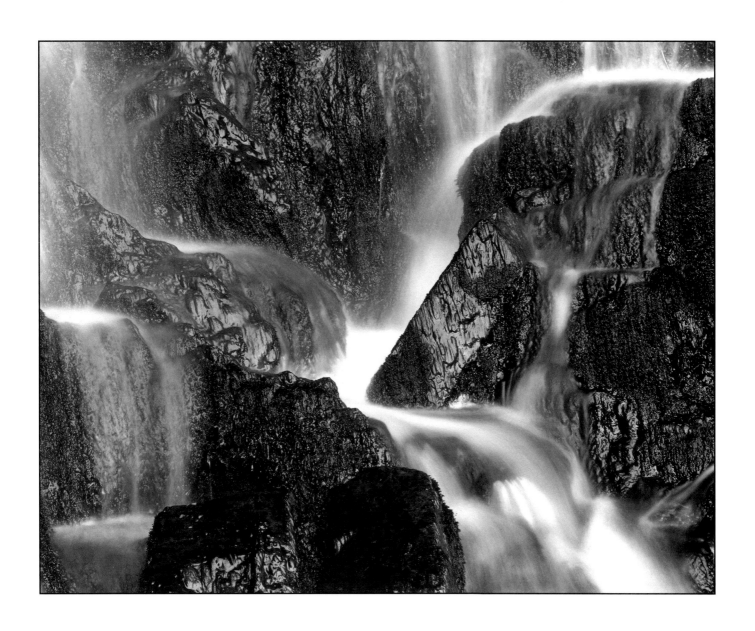

9
Water and wet rocks
Steve Terry

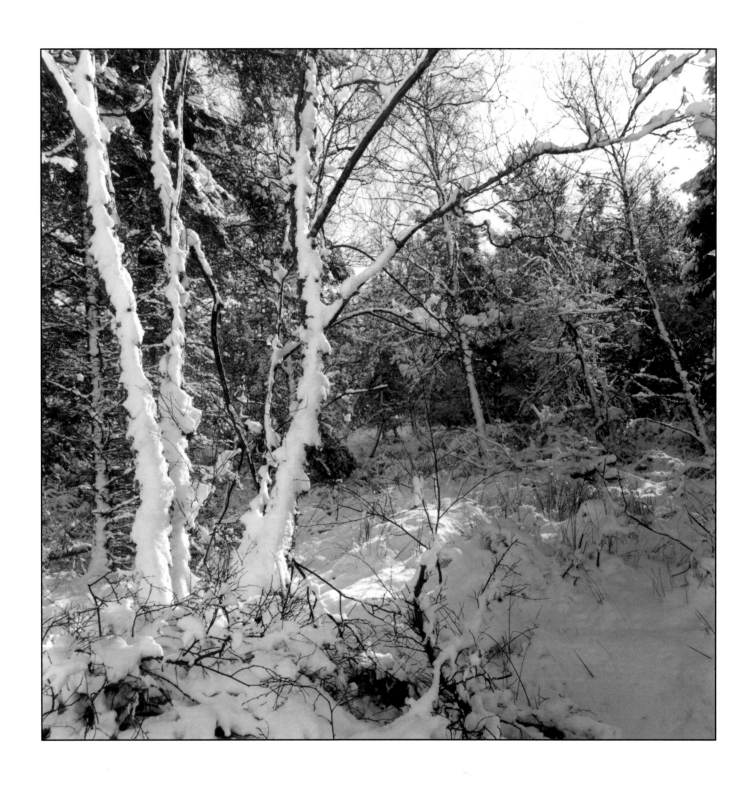

10
Forestry woodland, Ardross
Brian Poe

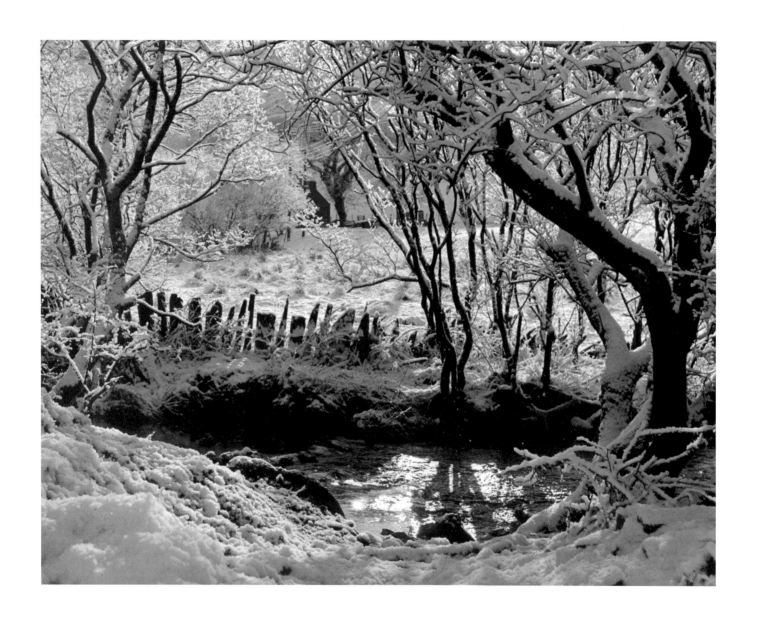

11
Eira Ebrill (April snow)
O Tudur Owen

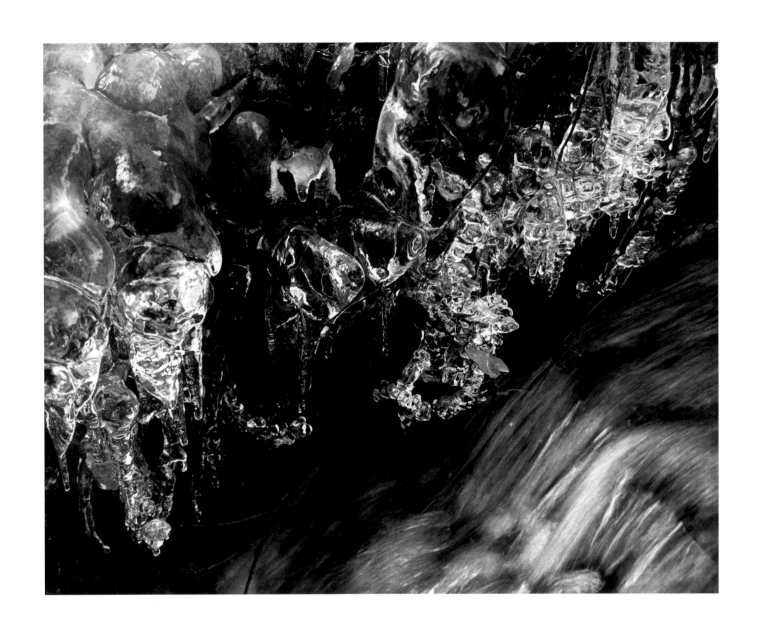

12
Ice at Stourhead
Andrew Hollingsworth

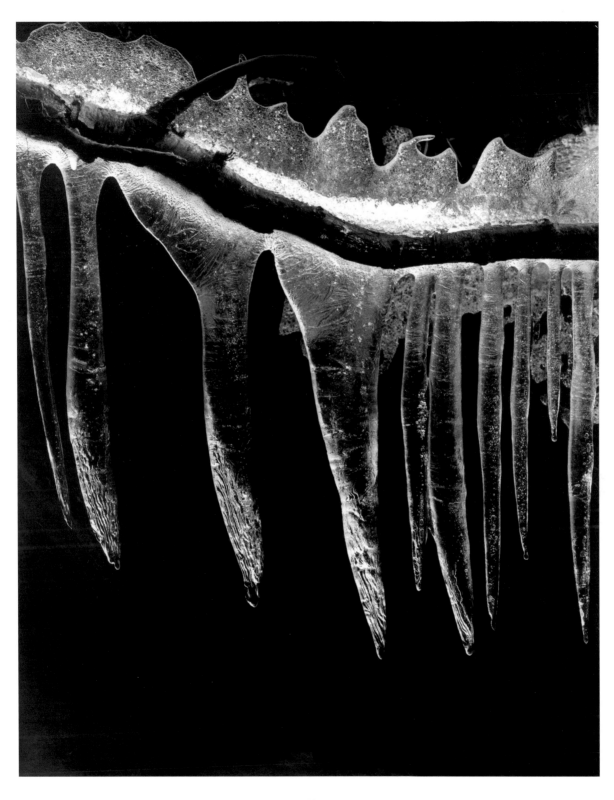

13
Icicles
Alfred Hoole

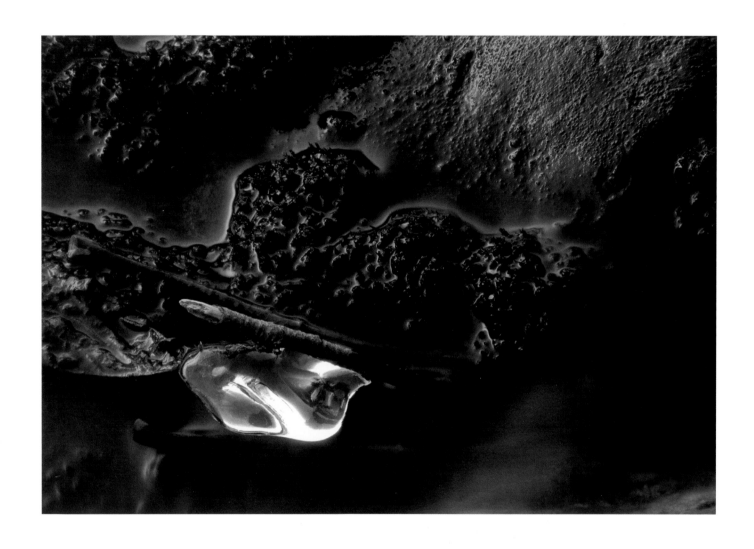

(above) 14 **Ice and twigs** *Len Perkis*
(top right) 15 **Ice art** *David Miller*
(bottom right) 16 **Ice bird and face** *David Miller*

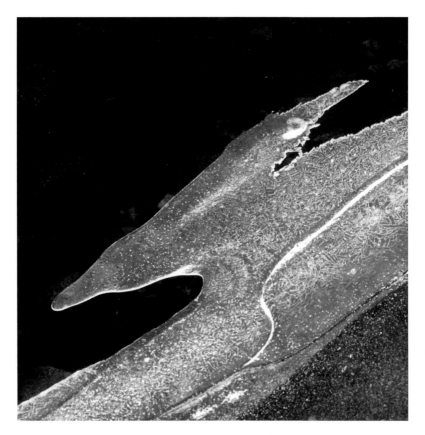

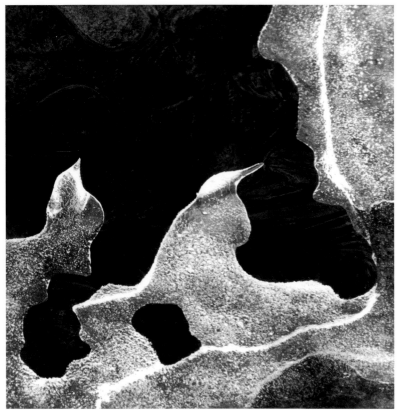

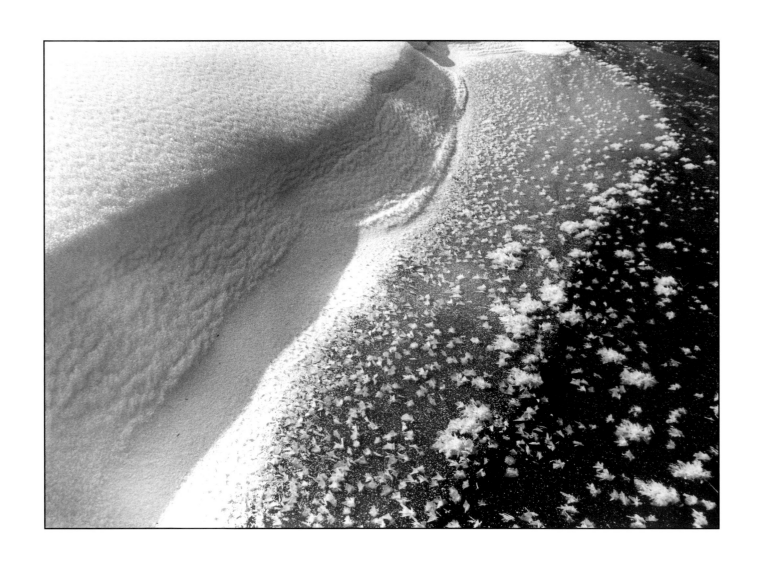

17
Frozen lake edge
Richard Clegg

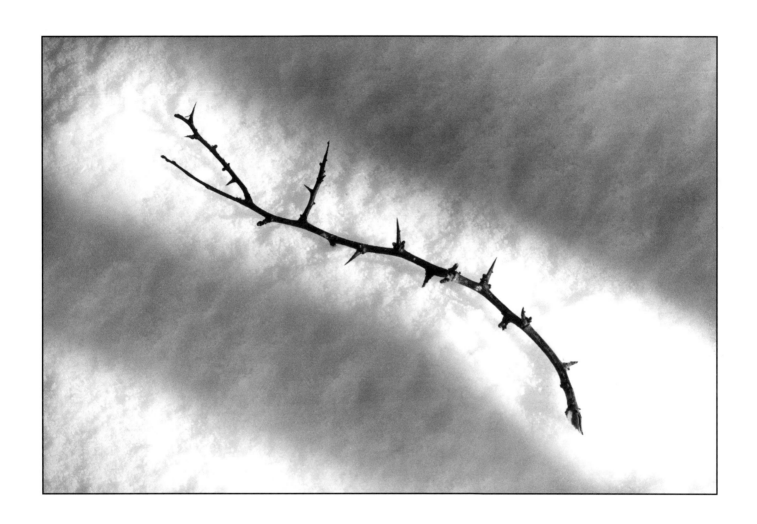

18
Sun, snow and twig
Hazel Sanderson

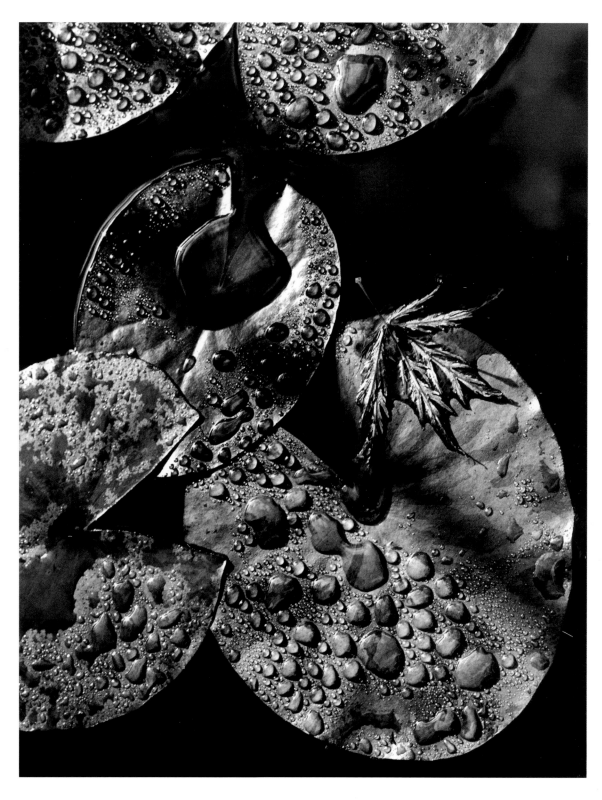

19
Sunshine after the shower
Hazel Sanderson

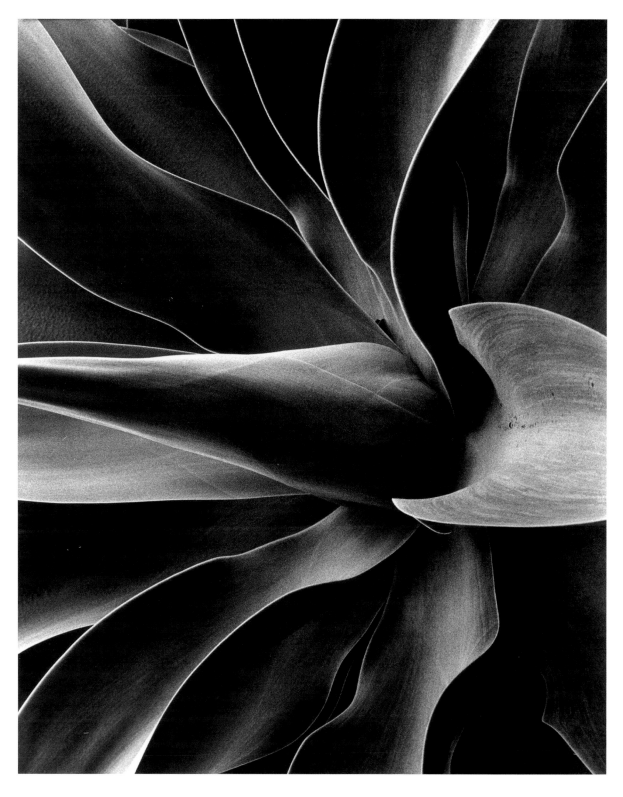

20
No title
David Martin

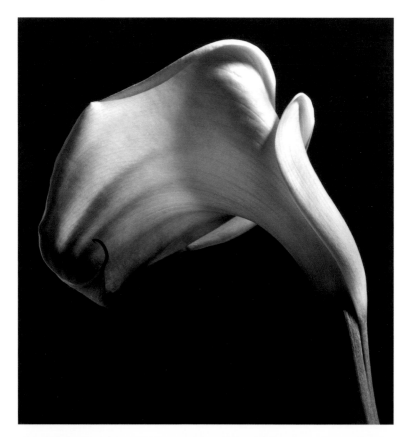

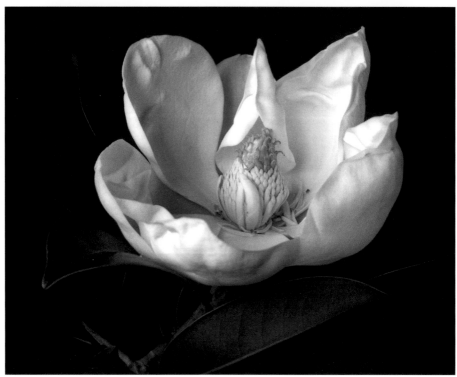

(top) 21 **Arum #3** *Mike Tinsley*
(bottom) 22 **Magnolia** *Mike Aamodt*

26

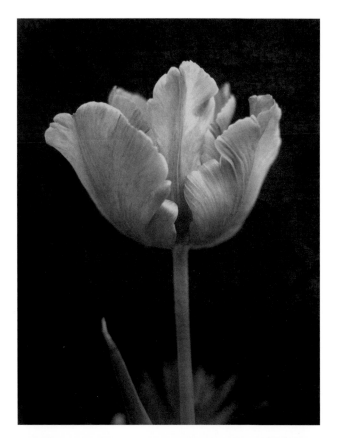

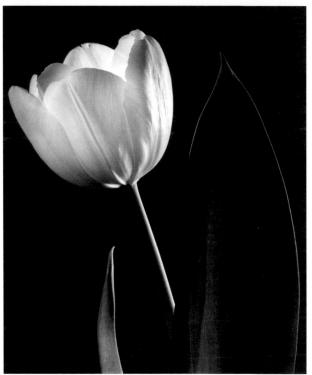

(top) 23 **Parrot tulip** *Sue Davies*
(bottom) 24 **Tulip** *Glen Ravenscroft*

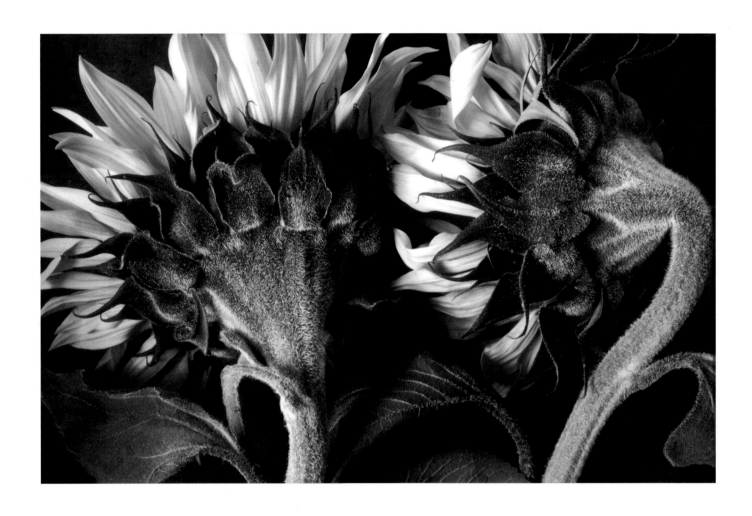

25
Two sunflowers
Den Reader

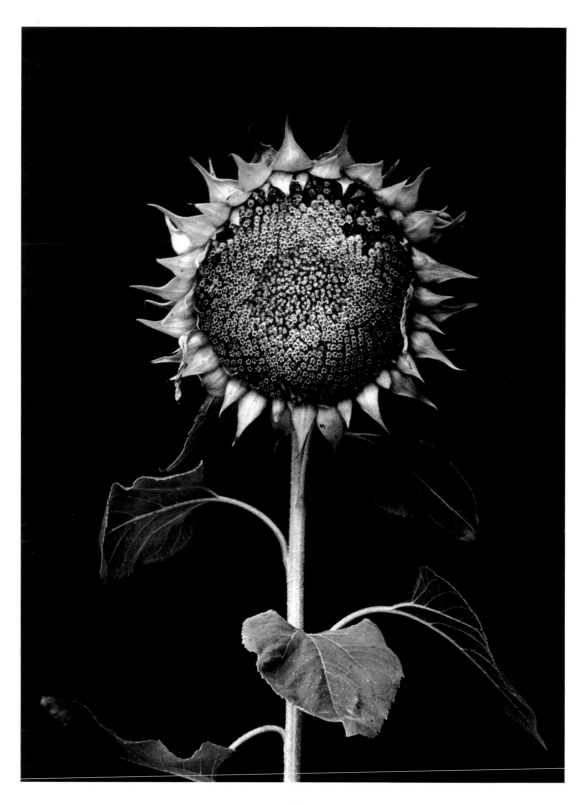

26
Sunflower #1
Caroline Hyman

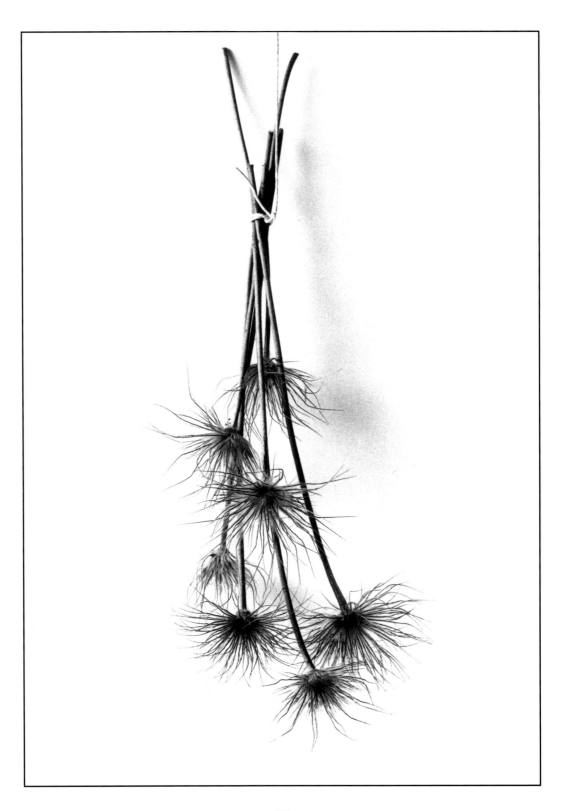

27
Pasque flower seed heads
Christine Chambers

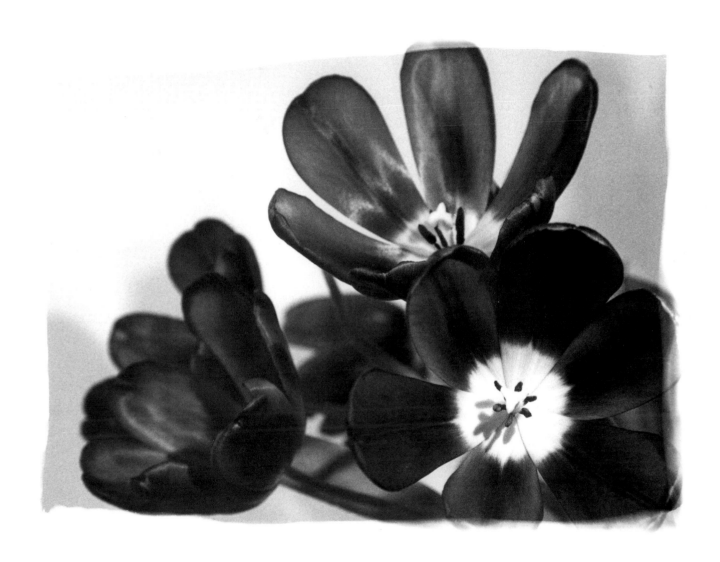

28
Untitled
Nenne van Dijk

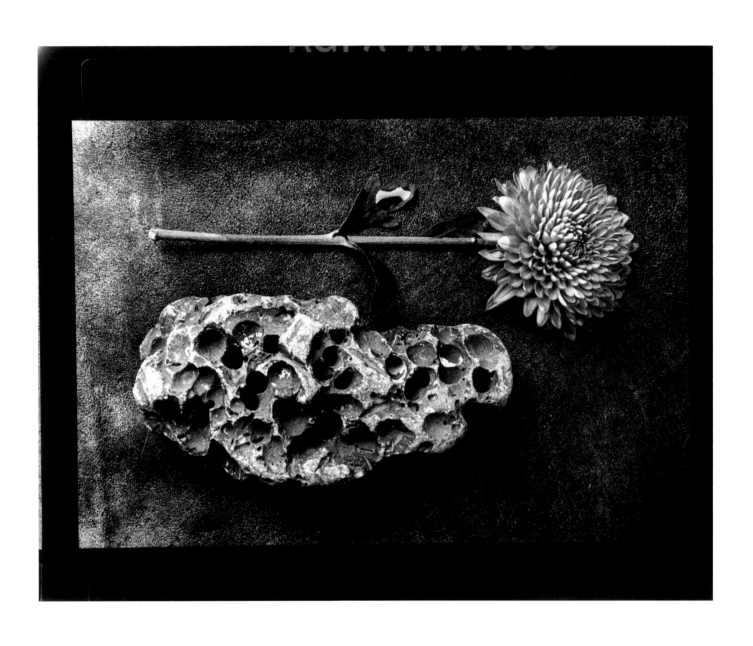

29
Stoneflower
Gary Corbett

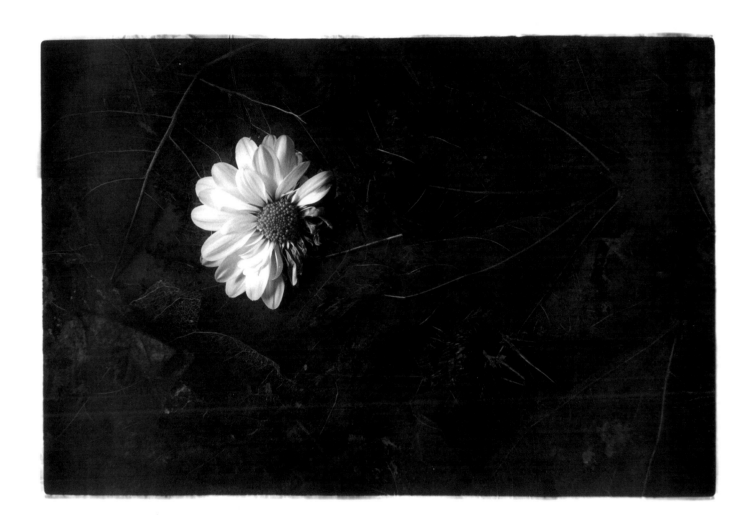

30
On the threshold
Patrick Rafferty

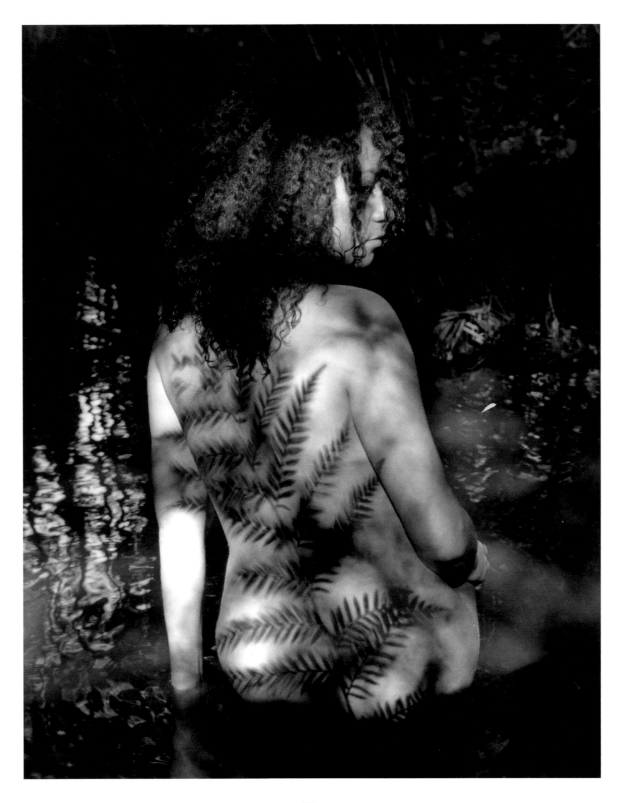

31
Captured
Shirlie Phillips

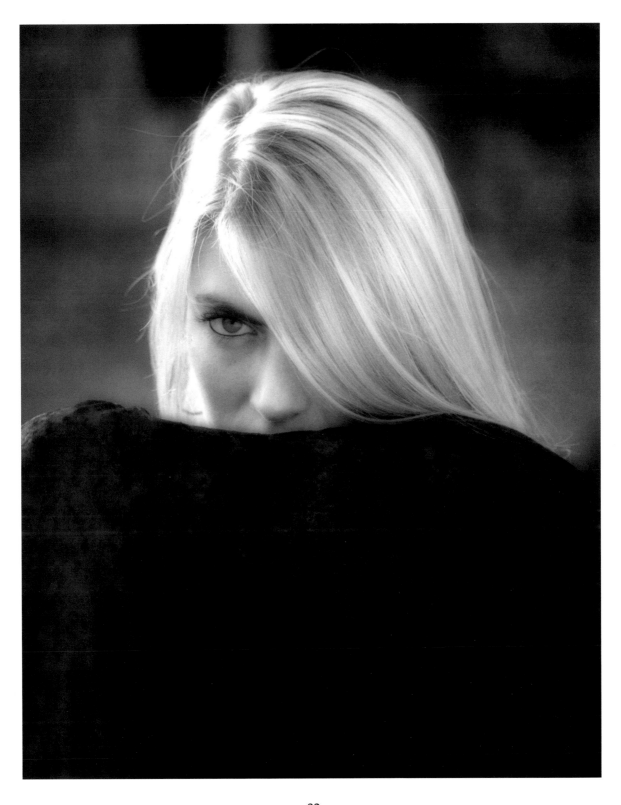

32
Eye contact
Nick Duncan

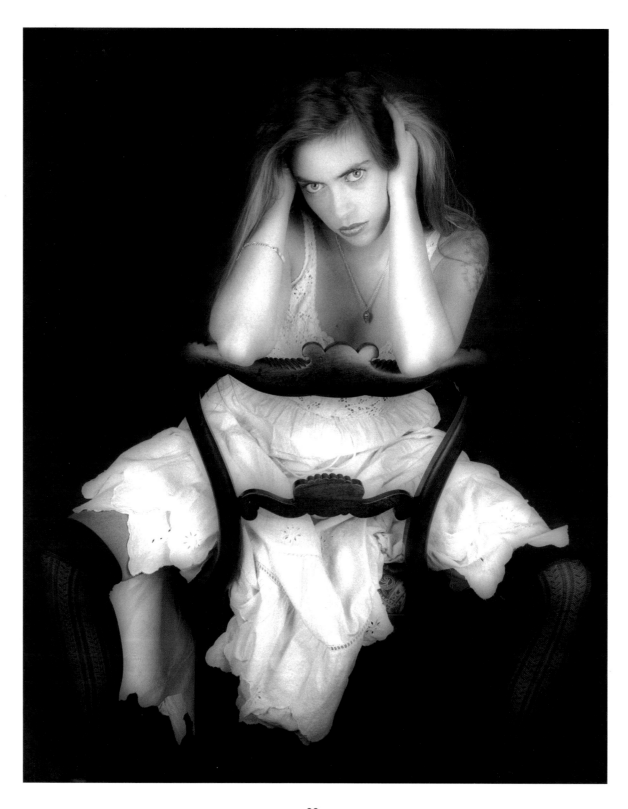

33
Karen
Nick Duncan

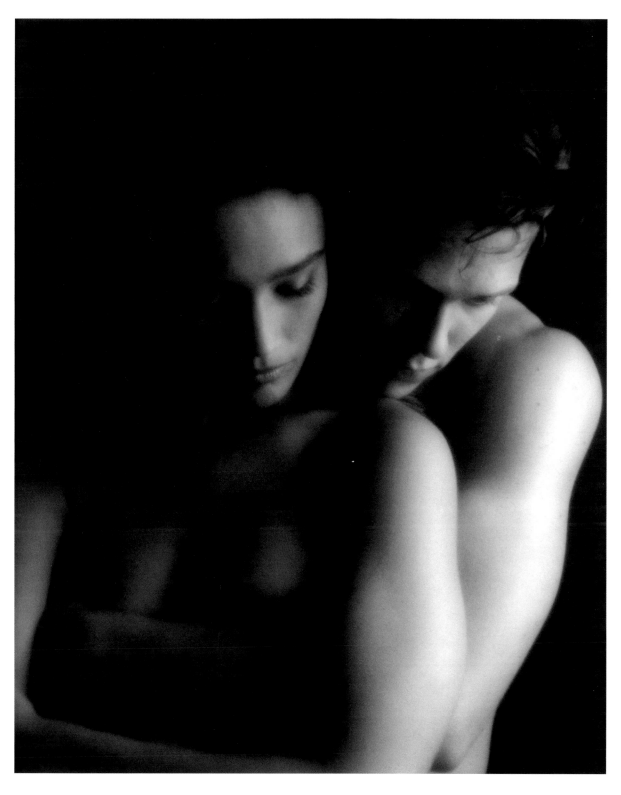

34
L'Amourette
Geoff Young

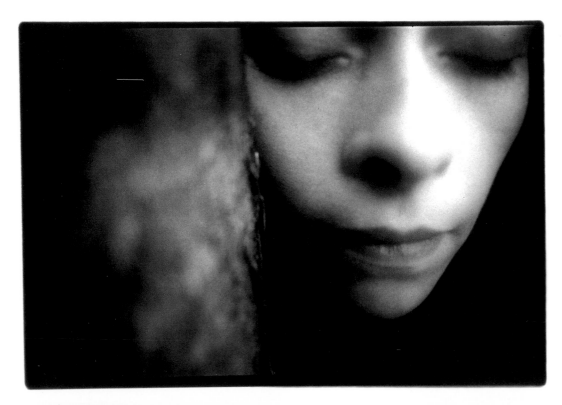

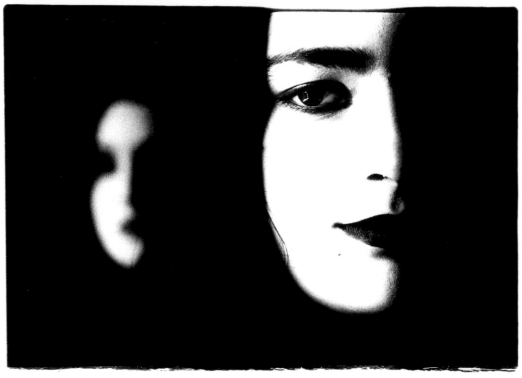

(top) 35 **Dreamwood** *Willie Dillon*
(bottom) 36 **Untitled I** *Willie Dillon*

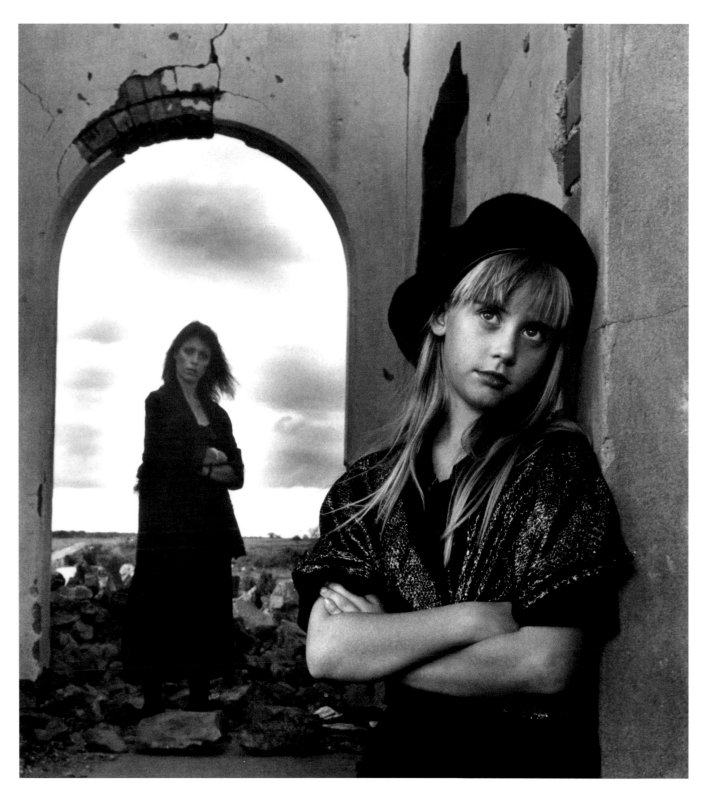

37
Belladonna
David Mahony

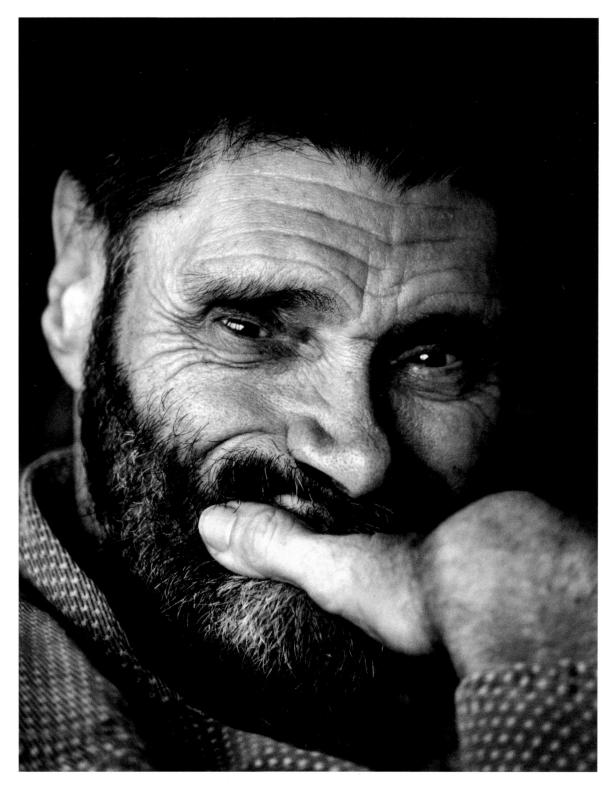

(above) 38 **Gerald** *Dave Prodrick*
(top right) 39 **Old soldier** *Edward Gordon*
(bottom right) 40 **Derwent Tyson** *John Fairclough*

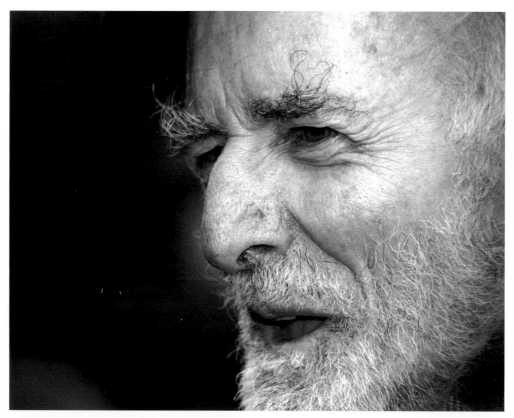

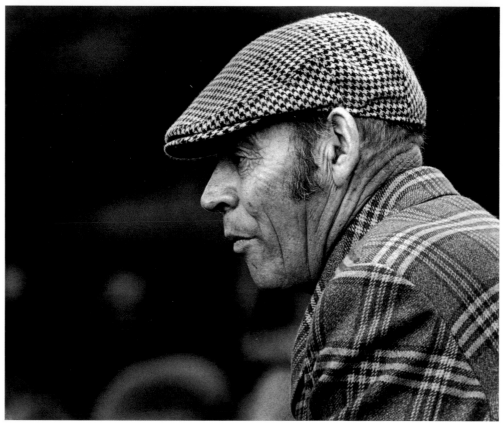

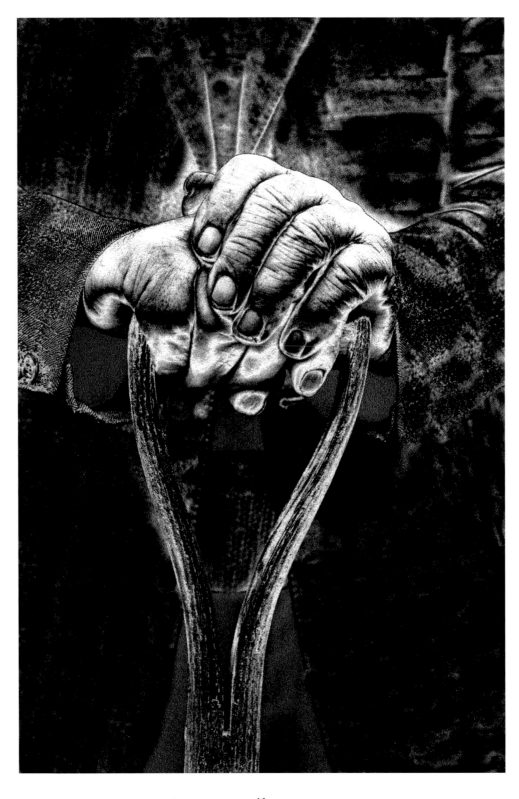

41
Hardwork
Steve Jackson

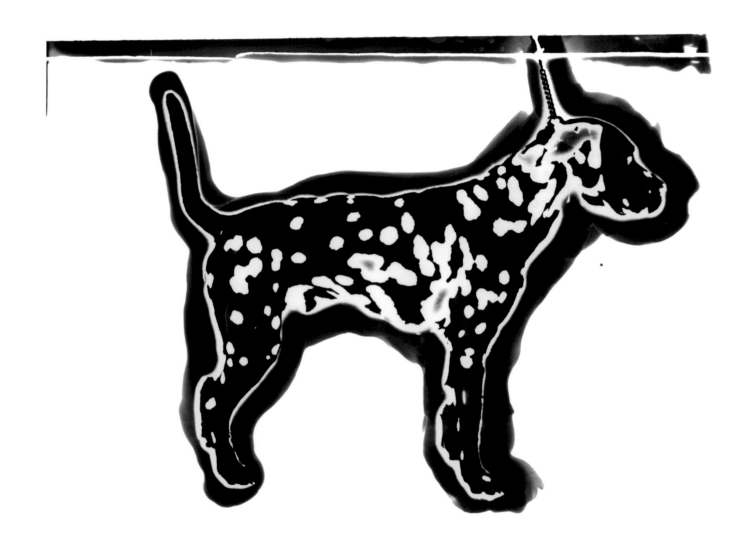

42
Spotty dog
Steven Cull

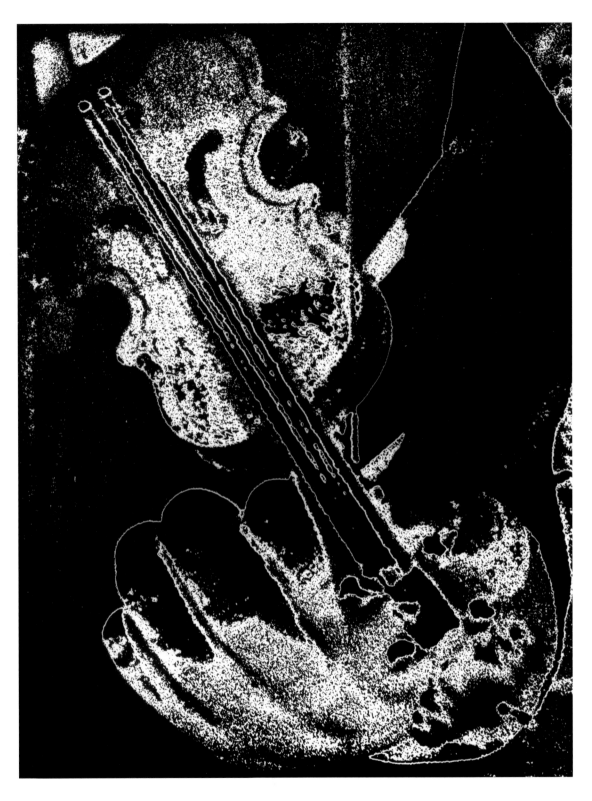

43
Violin
Daniel Toeg

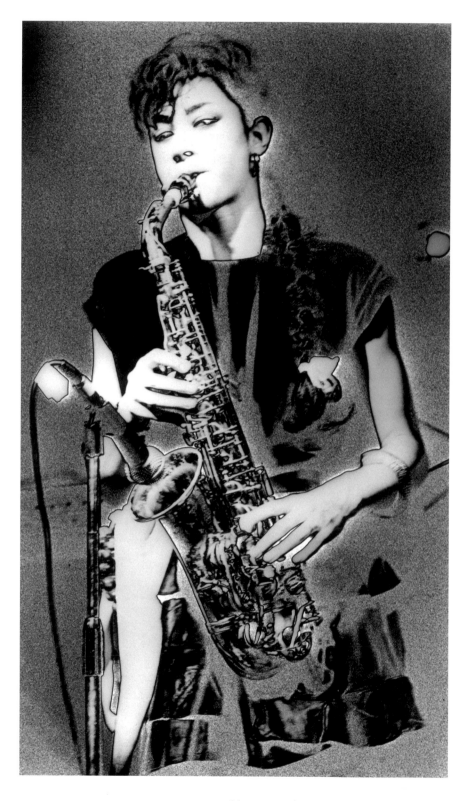

44
Solarock
Jim Wild

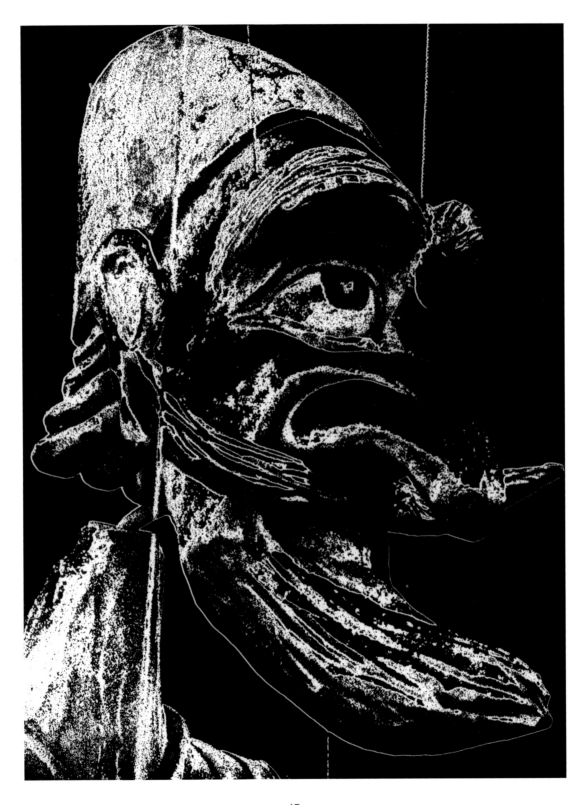

45
Puppet
Daniel Toeg

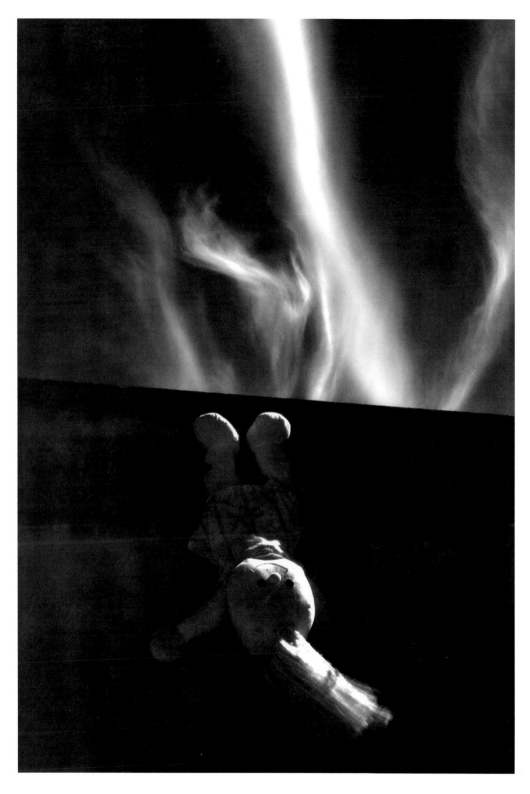

46
from 'The adventures of Hallucinating Annie'
Trevor Crone

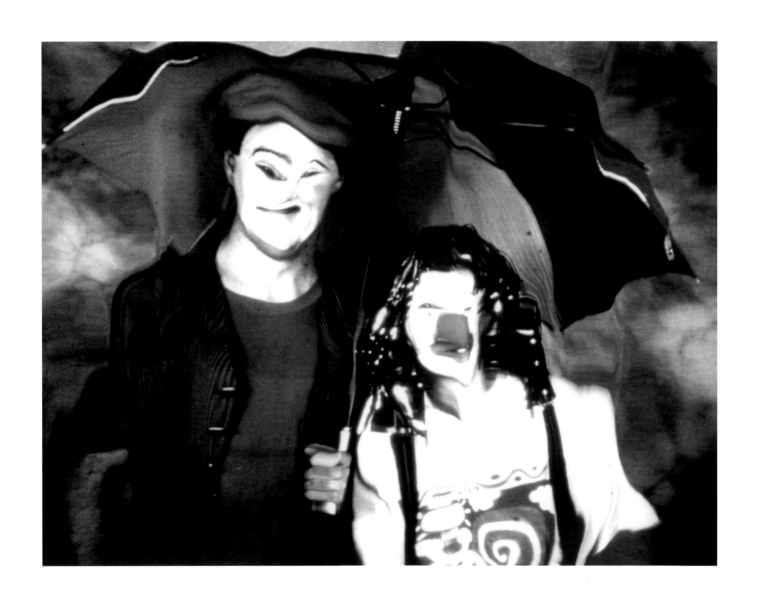

47
The clowns
Nick Ayers

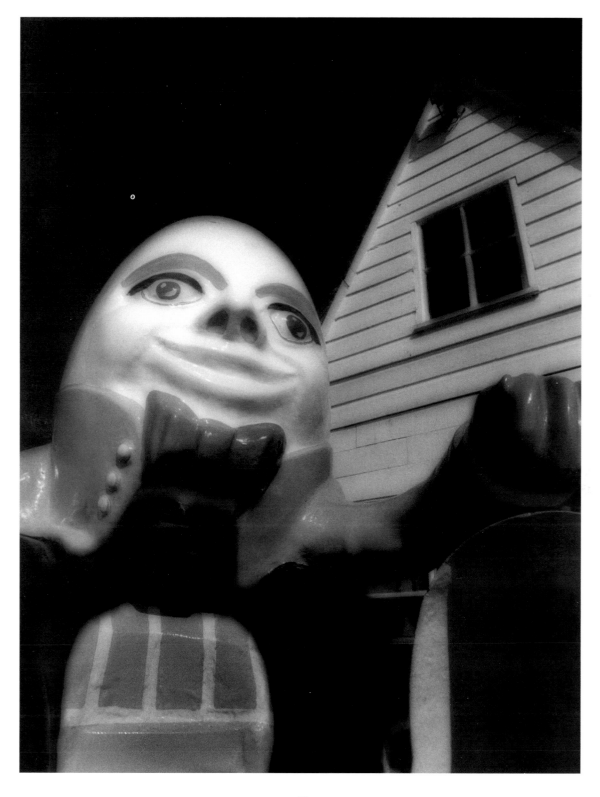

48
Hastings
Nick Duncan

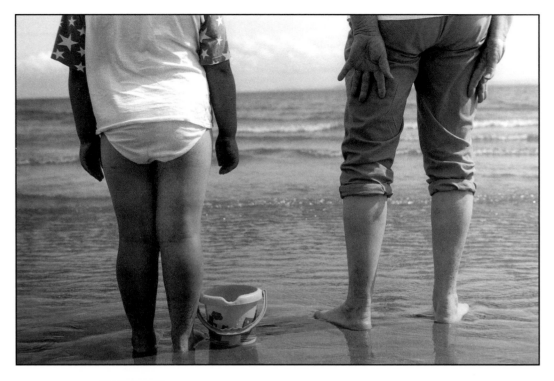

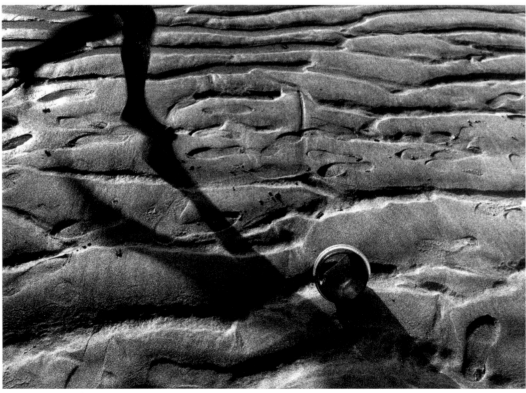

(top) 49 **Day at the seaside** *Ian King*
(bottom) 50 **Running man** *Karen Zalokoski*

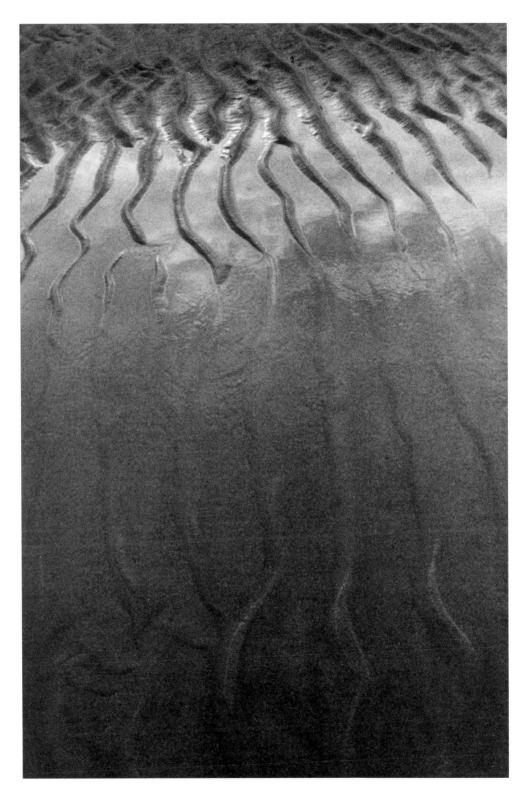

51
Low tide
Alan Brown (Tyne & Wear)

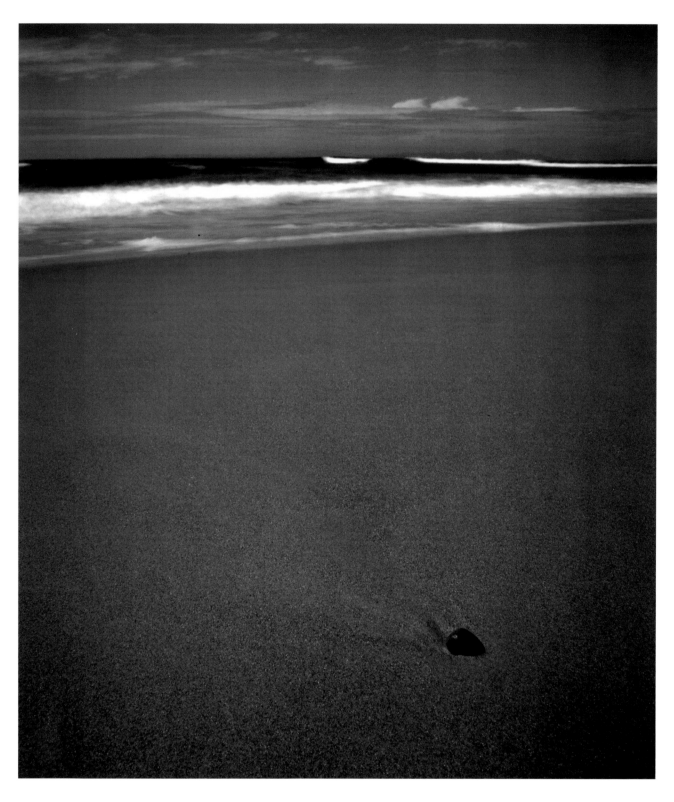

52
Stone on beach
Peter Williams

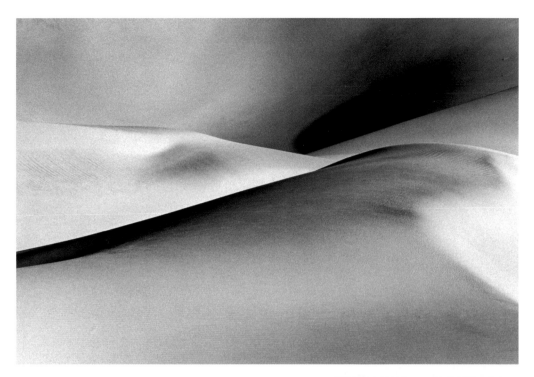

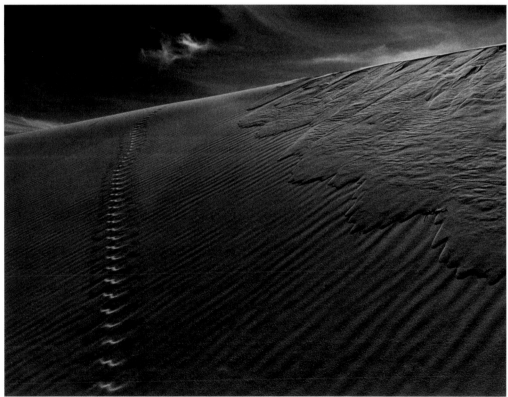

(top) 53 **Sand forms, Death Valley** *John Devenport*
(bottom) 54 **Desert tracks** *Stephen Husbands*

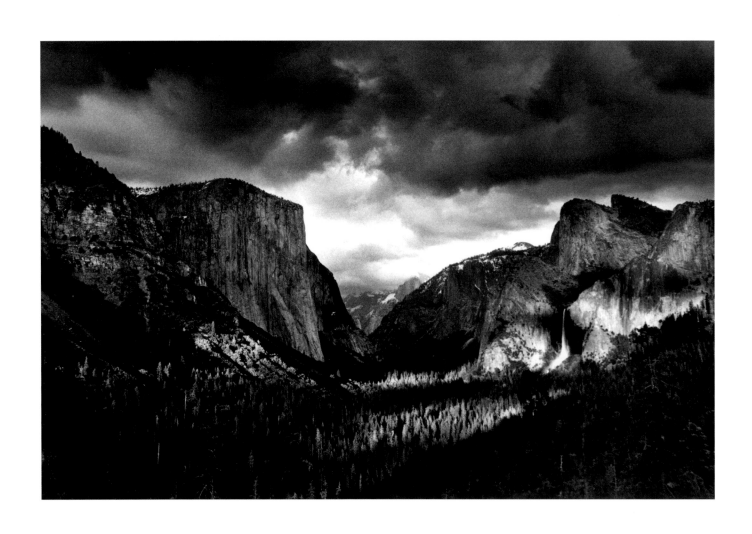

55
Yosemite Valley #1
Peter Clark

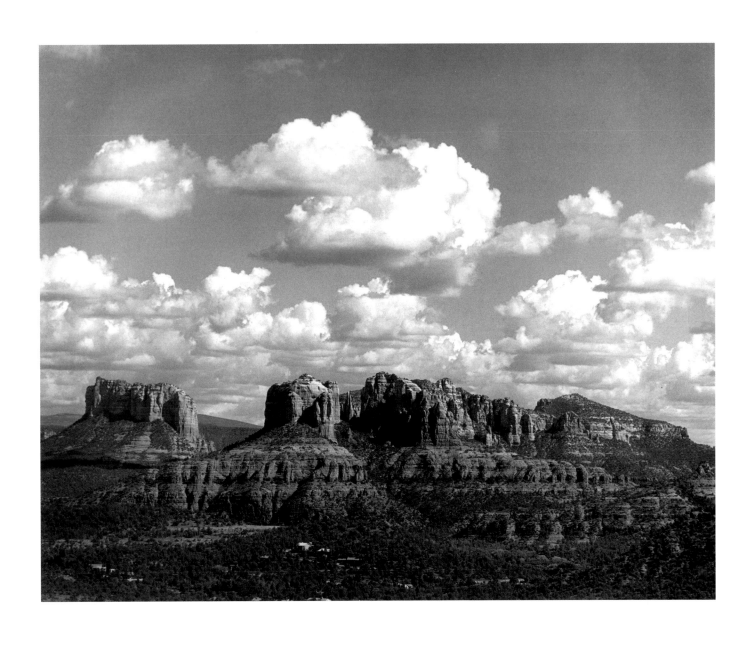

56
Rockscape, Sedona
Mark Fohl

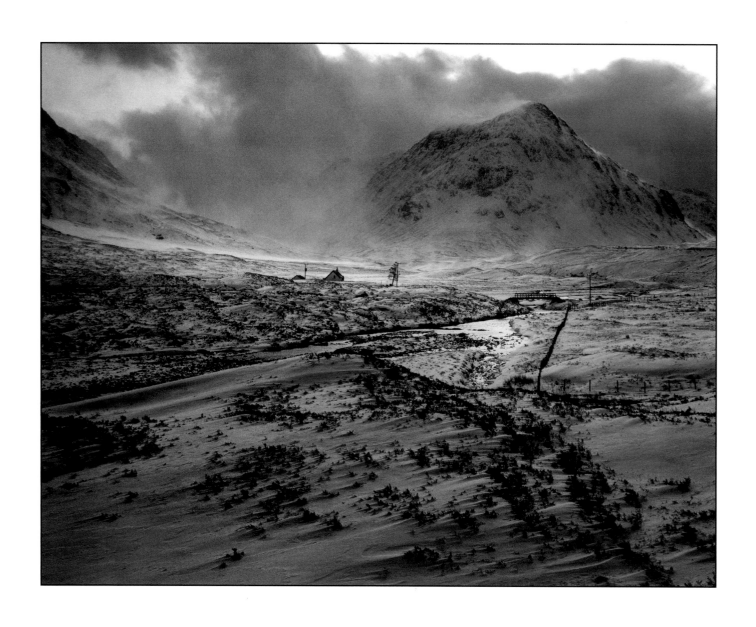

57
Glencoe
Ken Huscroft

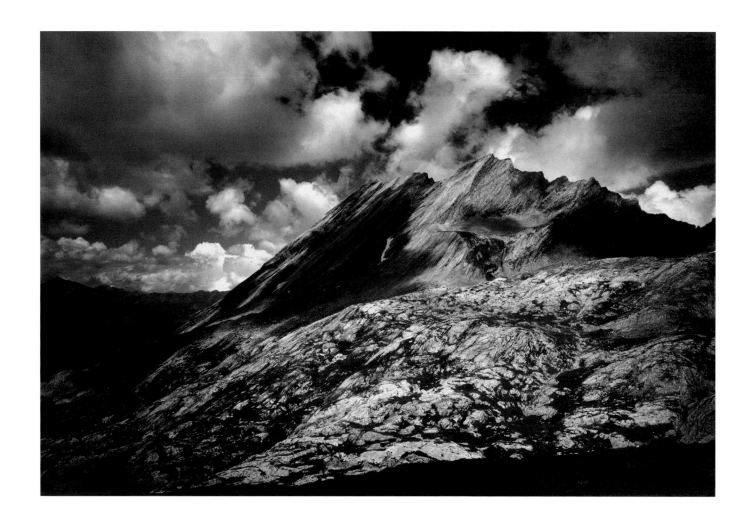

58
Crête de la Taillante
Bob Marshall

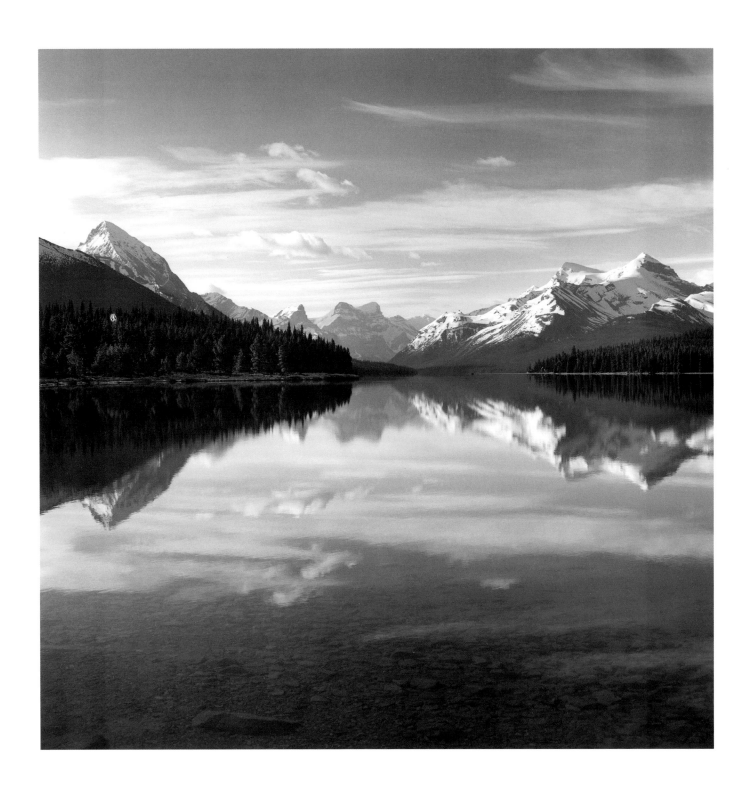

59
Maligne Lake, Jasper, Canada
Kevin Bridgwood

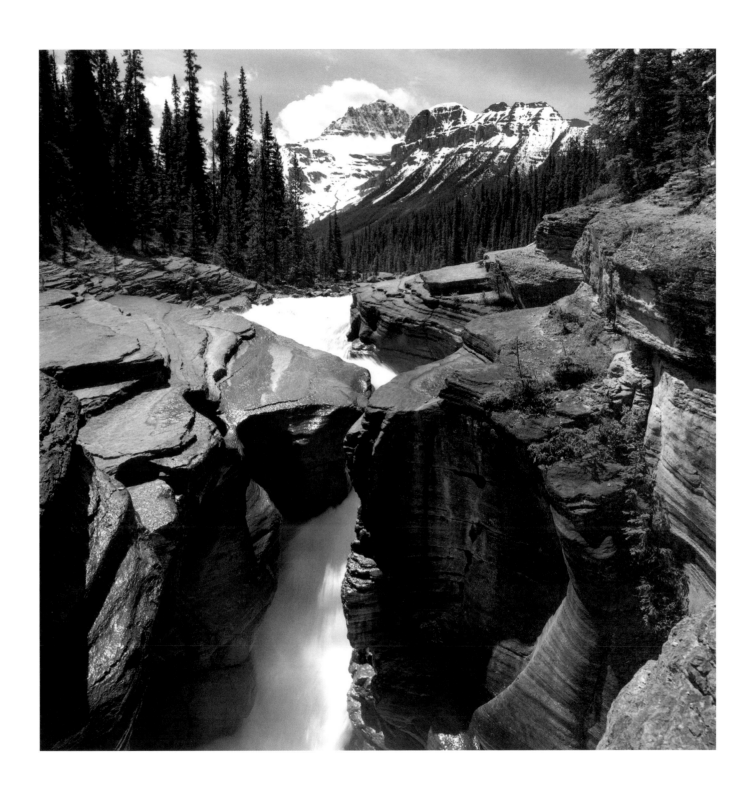

60
Clashing Rocks, Mistaya Canyon, Alberta, Canada
Kevin Bridgwood

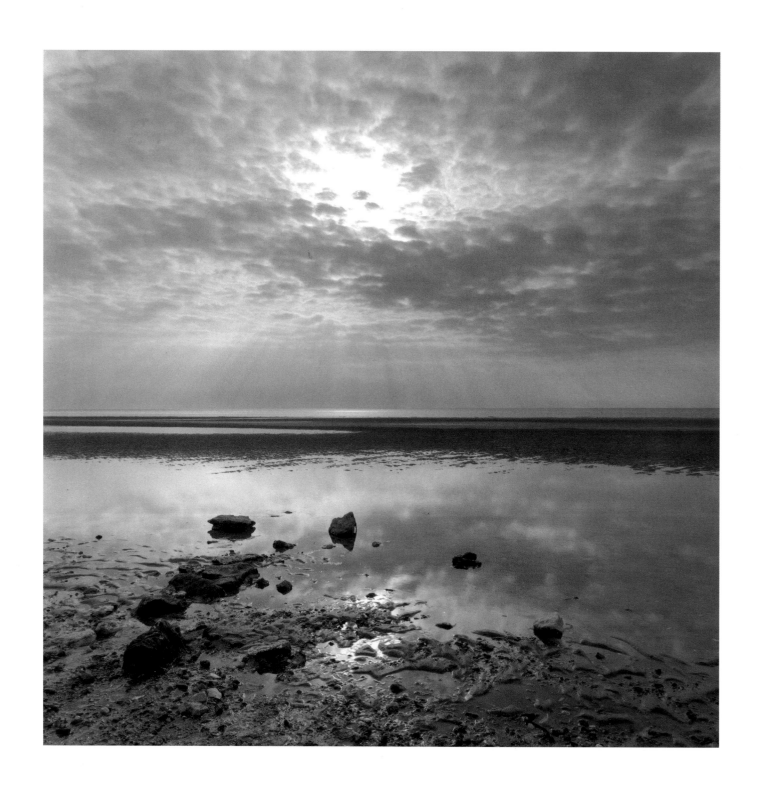

61
Hunstanton beach, Norfolk
John Fenn

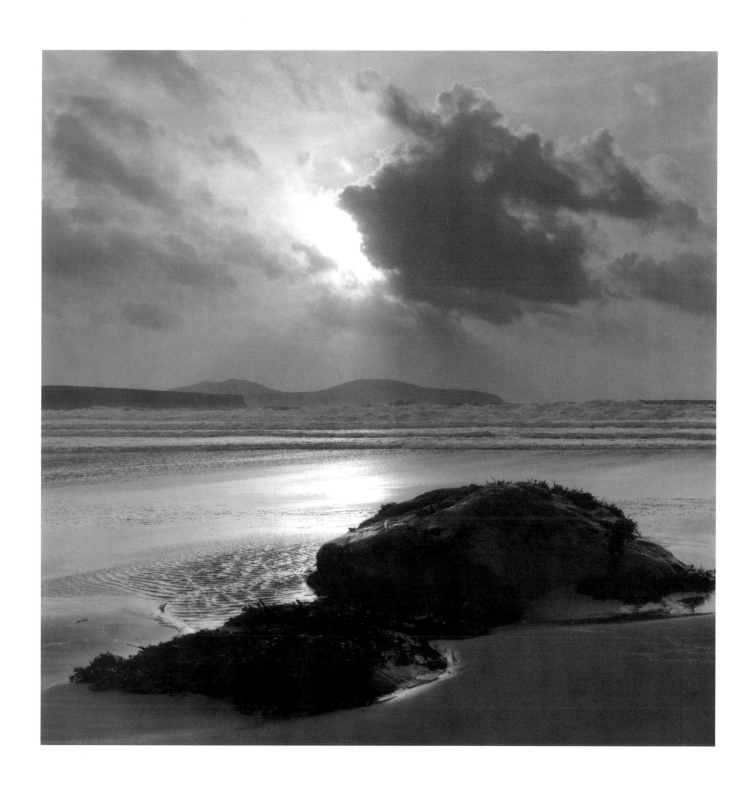

62
Whitesands Bay, Pembrokeshire
John Fenn

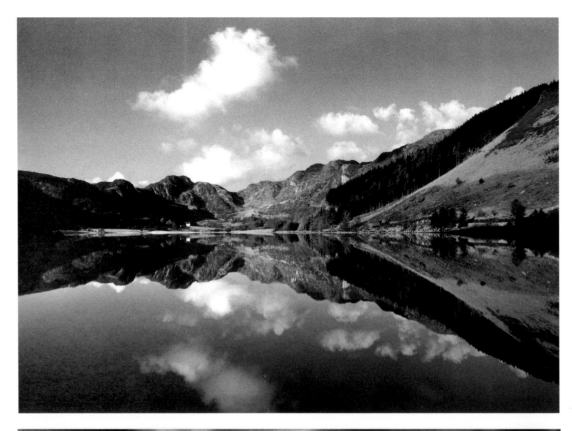

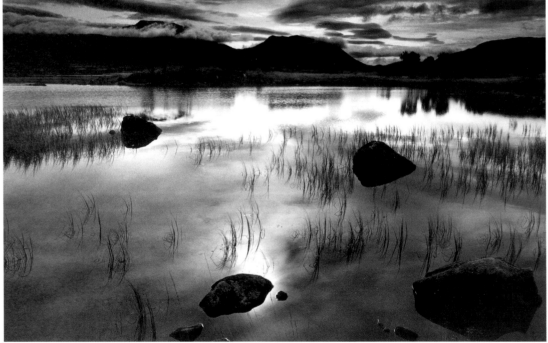

(top) 63 **Llyn Crafnant** *Paul Webster*
(bottom) 64 **Rannoch Moor** *Brian Ebbage*

62

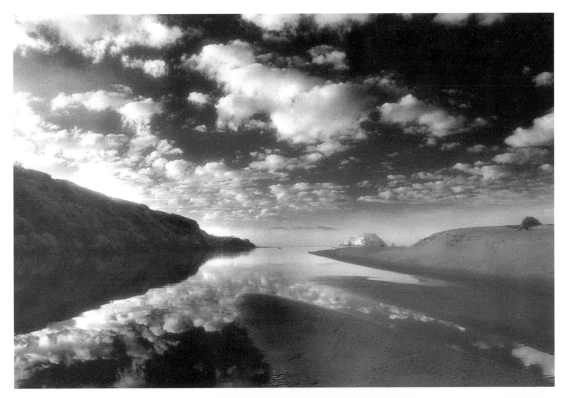

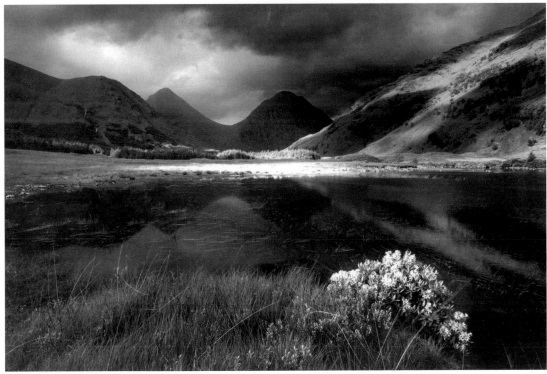

(top) 65 **Louisa River Mouth** *Michael Calder*
(bottom) 66 **Highland tranquillity** *David Milano*

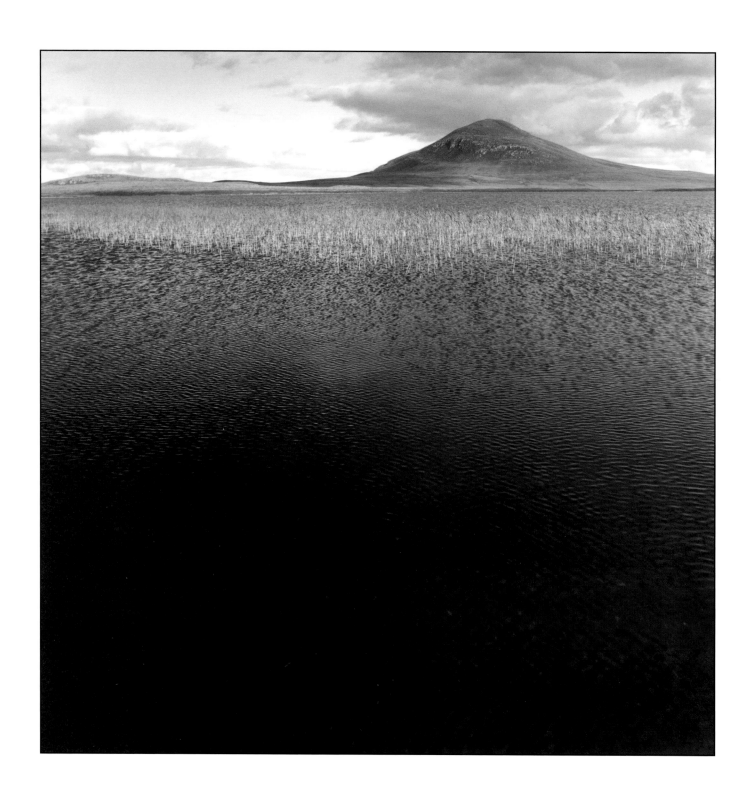

67
Loch Coire nam Mang
Brian Poe

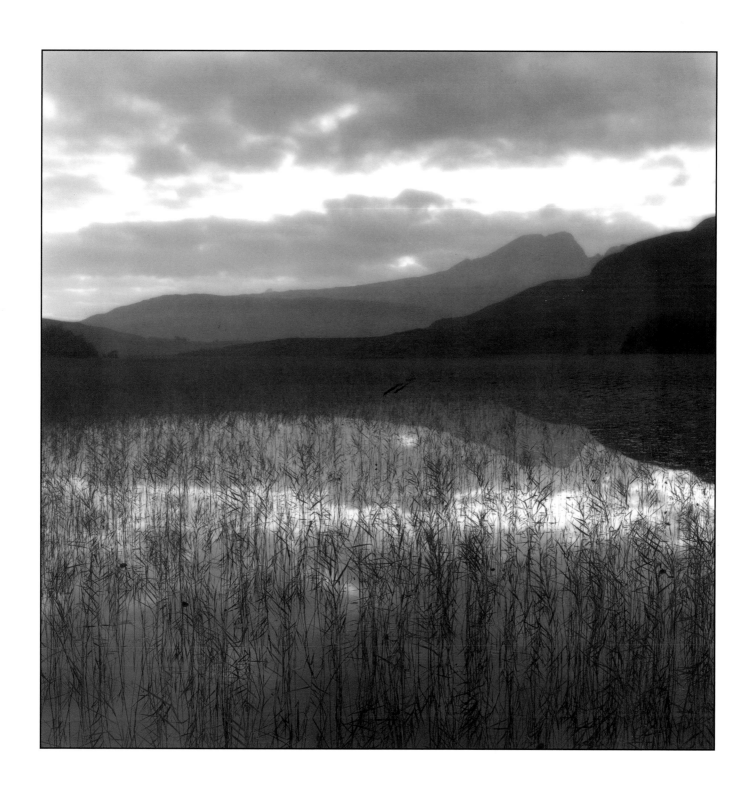

68
Loch Cill Chriosd #3
Mark Snowdon

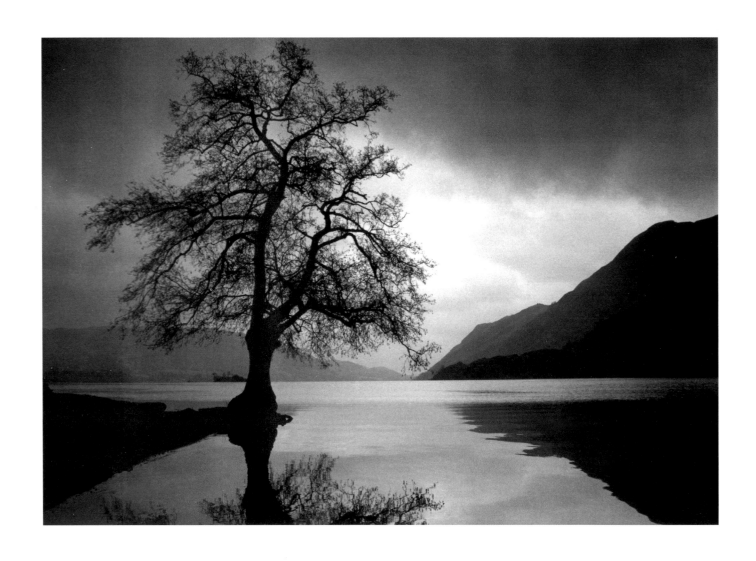

69
Ullswater
Tom Richardson

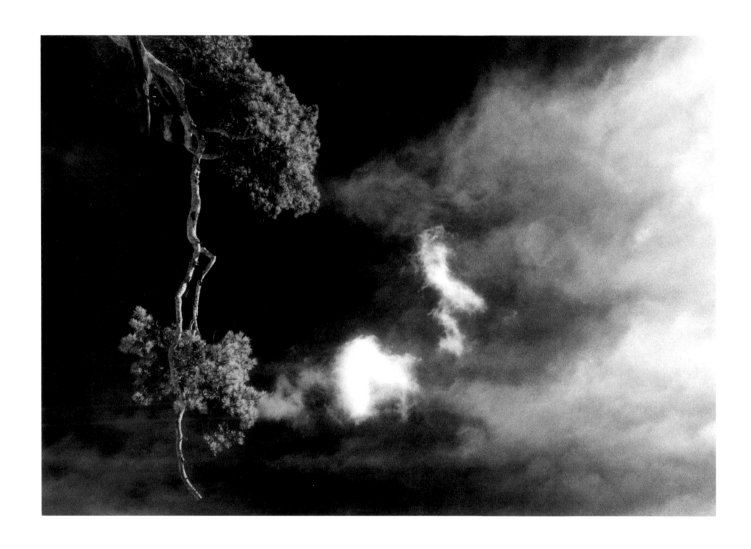

70
Skinny legs
Denis Bourg

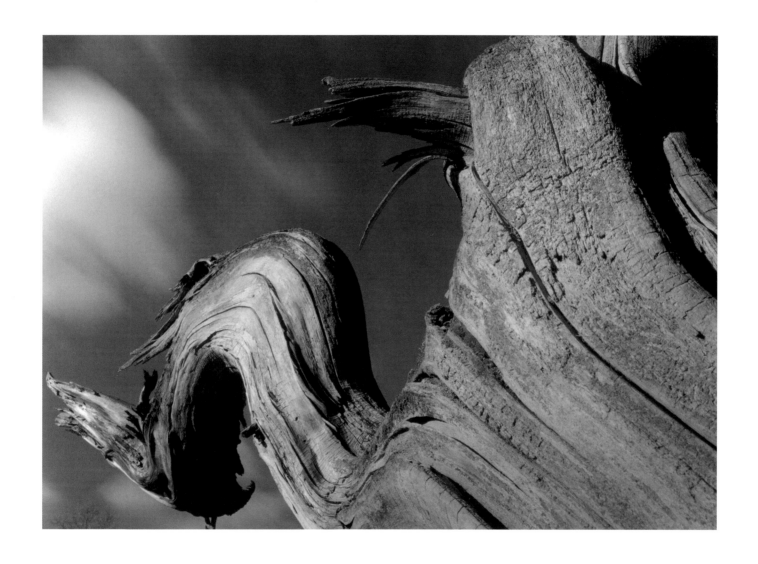

71
Tree details
Paul Webster

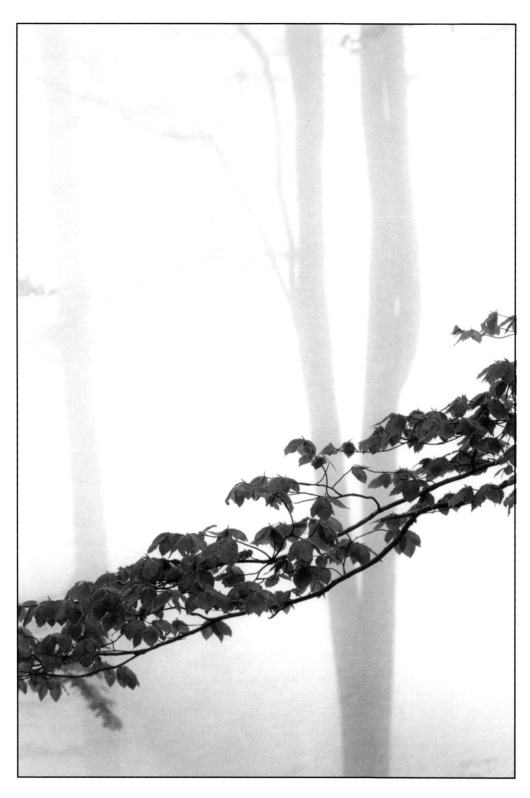

72
Fog in forest #2
Jiri Bartos

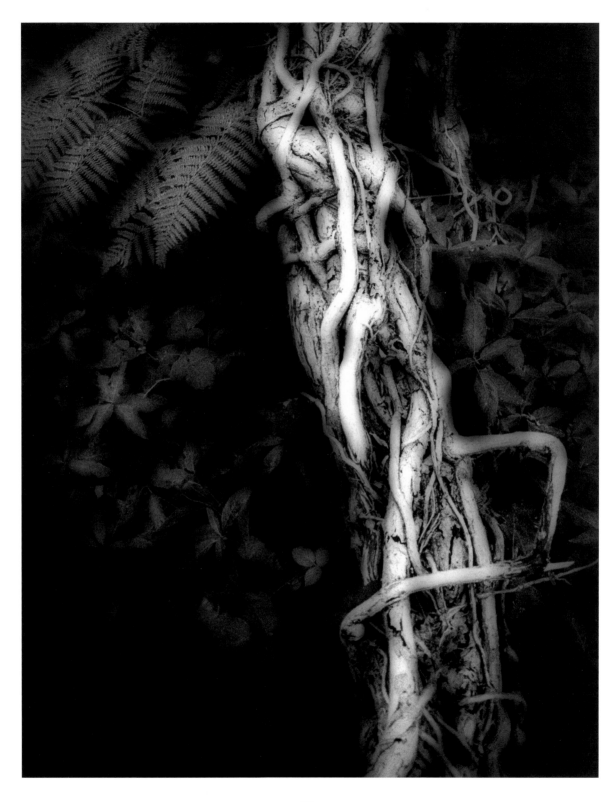

73
Entwined III
Neil Bedwell

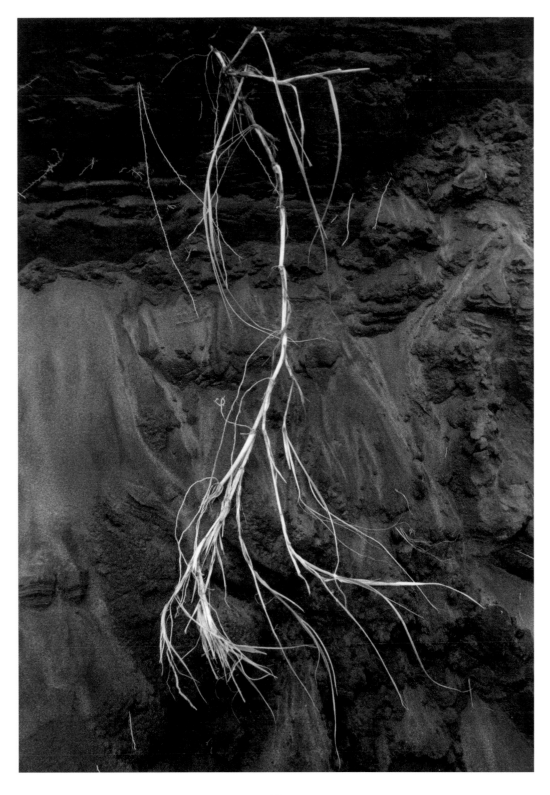

74
Grass roots
Cliff Threadgold

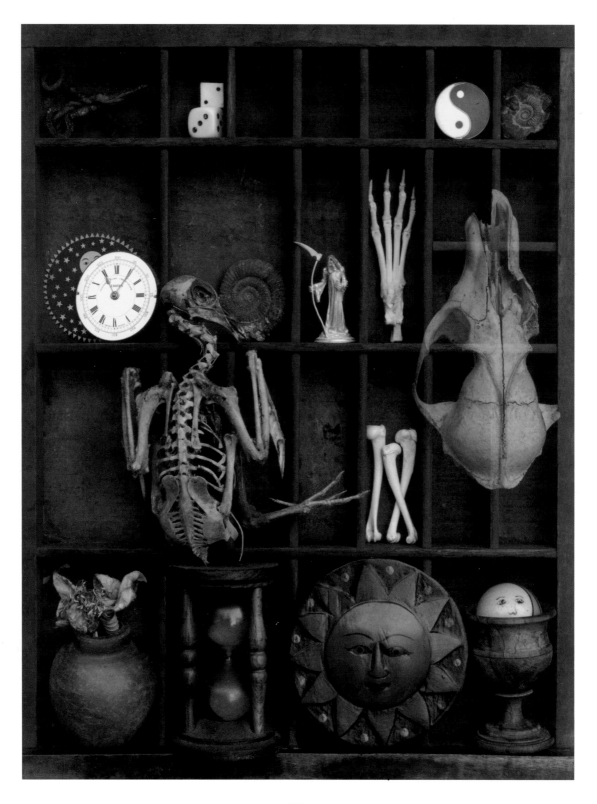

75
The enigma of time #2
Trevor Crone

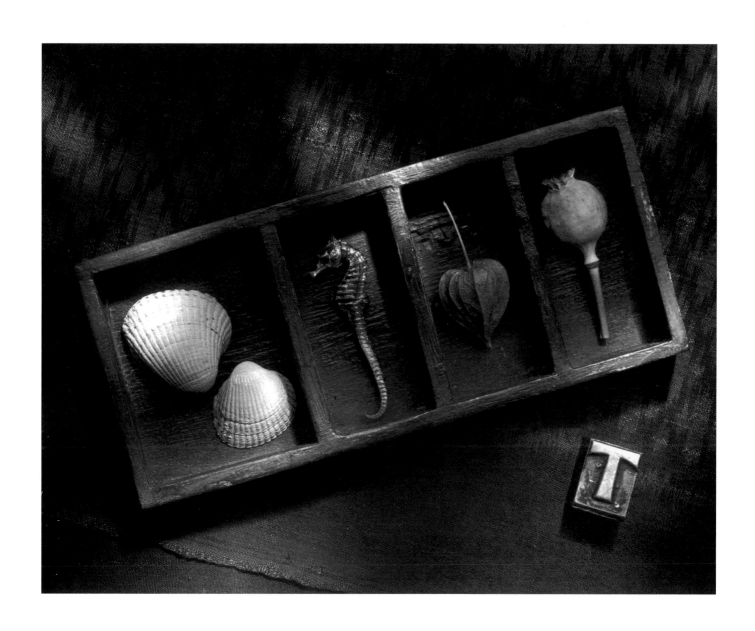

76
Tricia's treasures
Robert Kirchstein

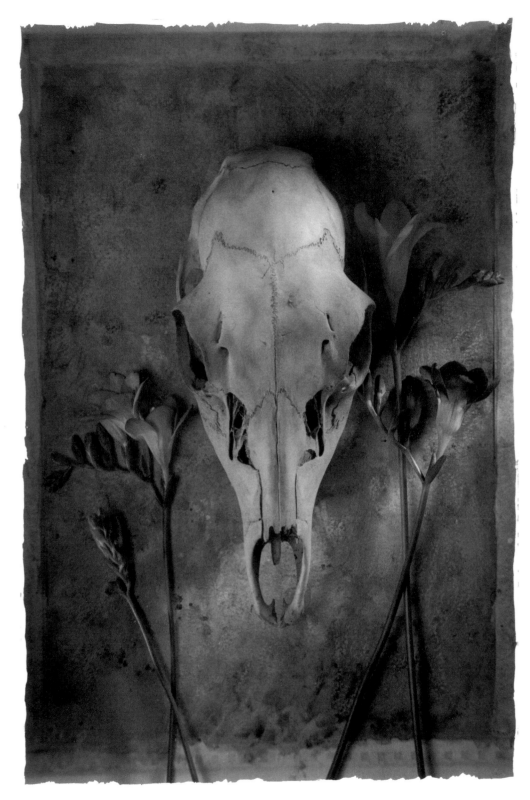

77
Deer skull and freesias
Charles Baynon

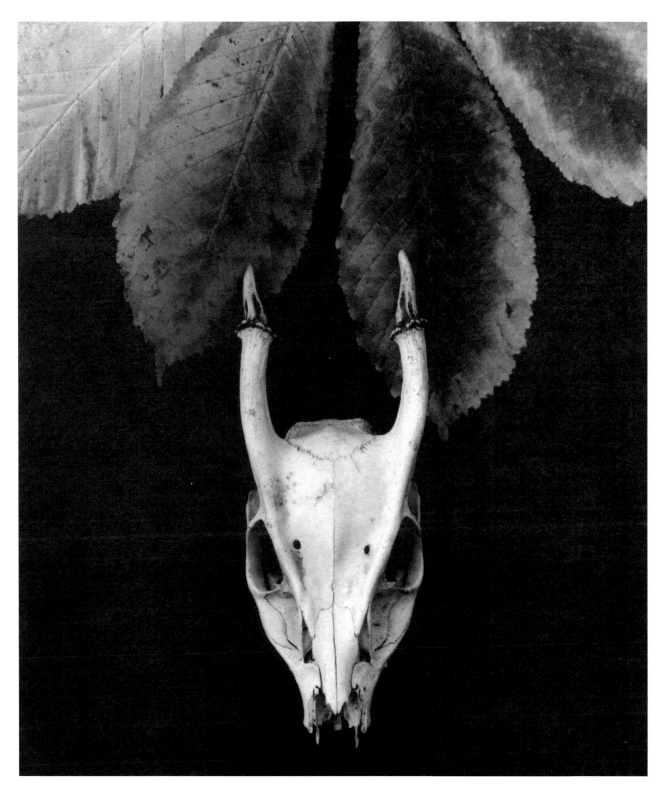

78
Muntjac head
Caroline Hyman

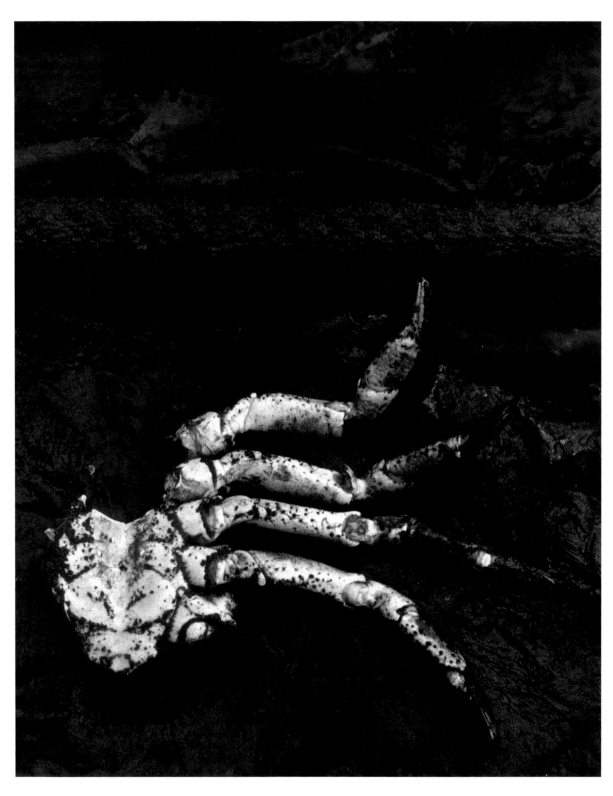

79
Crustation on film
Neil Gibson

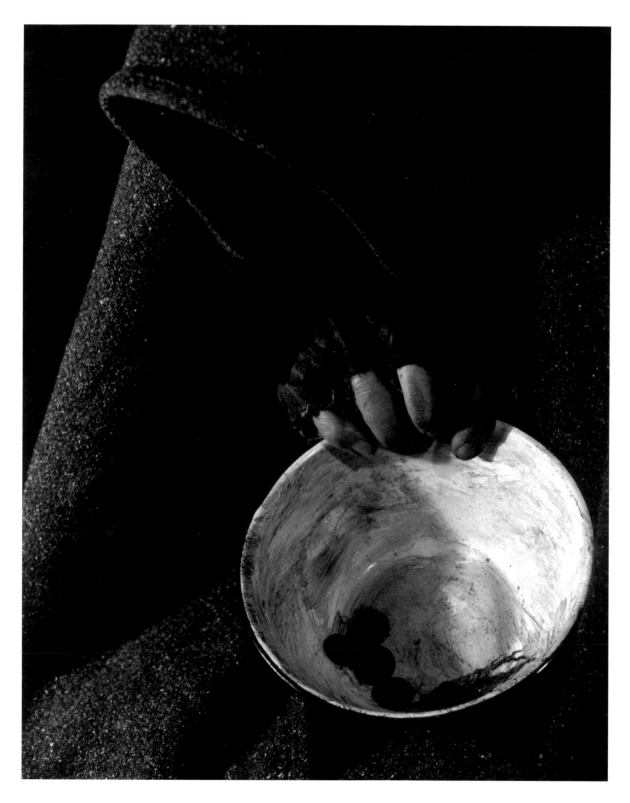

80
The begging bowl
Bob Stevenson

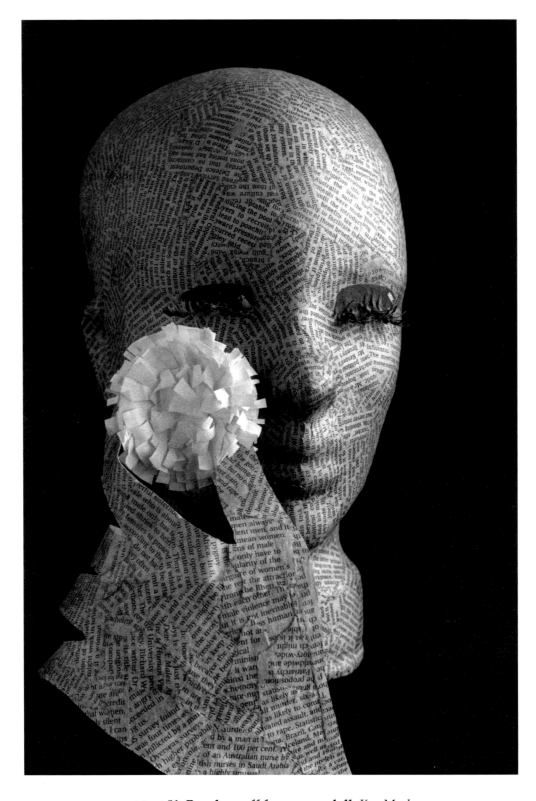

(*above*) 81 **Powder puff for a paper doll** *Kay Mack*
(*top right*) 82 **The innocent** *Margaret Salisbury*
(*bottom right*) 83 **Boy meets girl** *Den Reader*

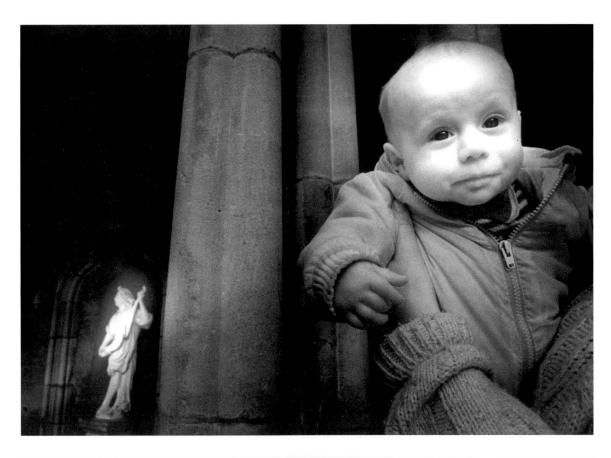

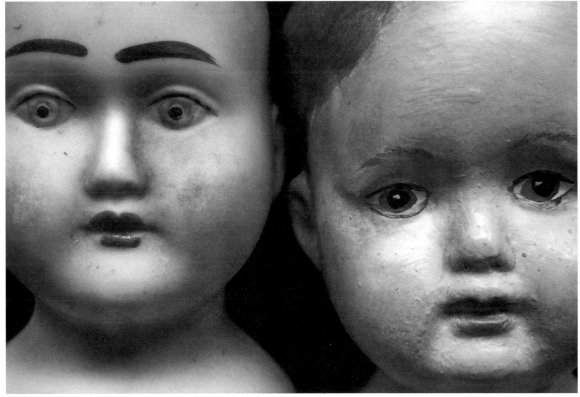

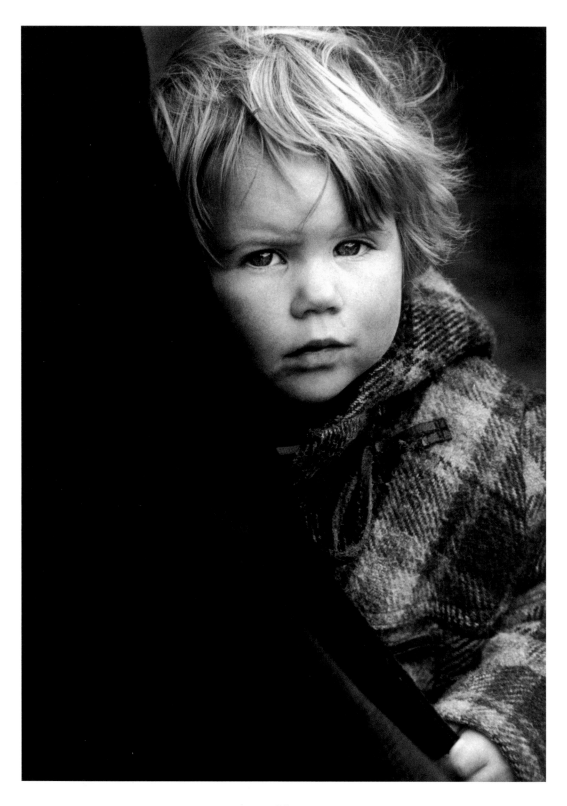

84
Claire
Michael Cant

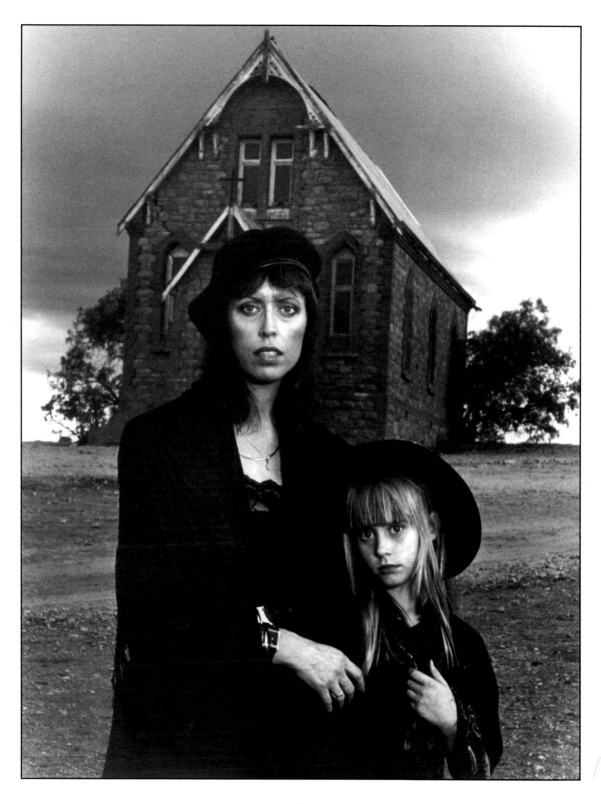

85
Miserere
David Mahony

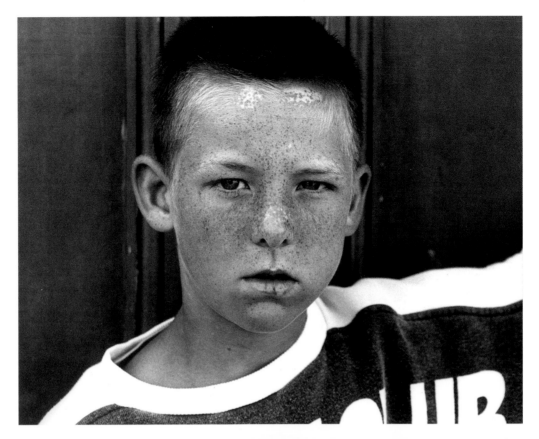

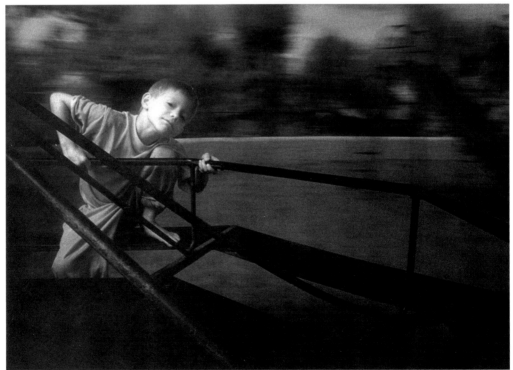

(top) 86 **Guernsey boy** *Klaus Peters*
(bottom) 87 **Playground memory** *Christopher Read*

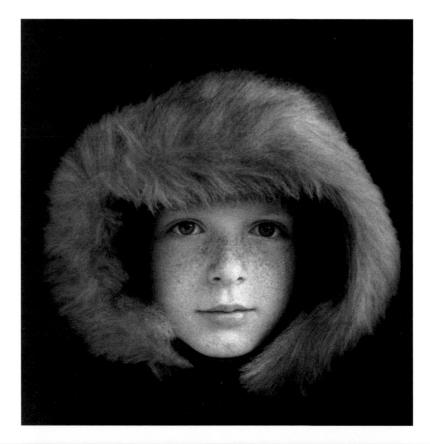

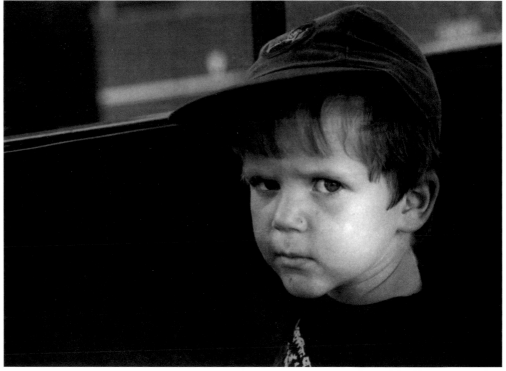

(top) 88 **Carol** *Pat Canavan*
(bottom) 89 **Richard** *Frank Phillips*

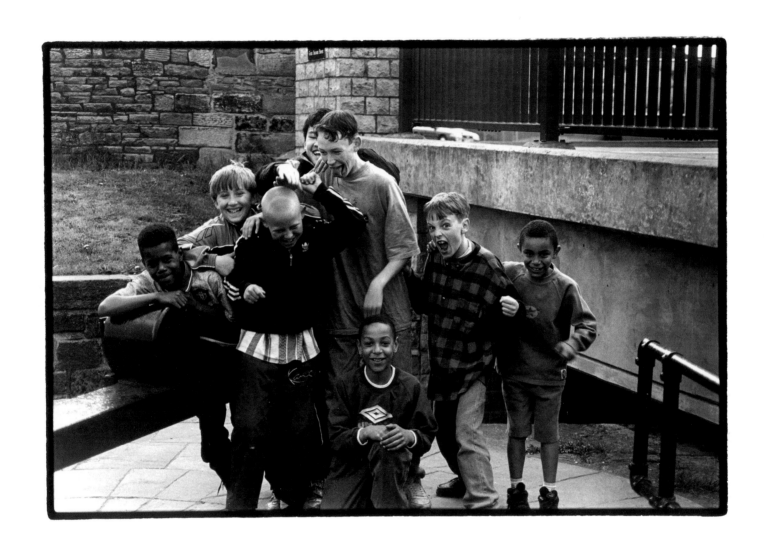

90
Our gang
David Couldwell

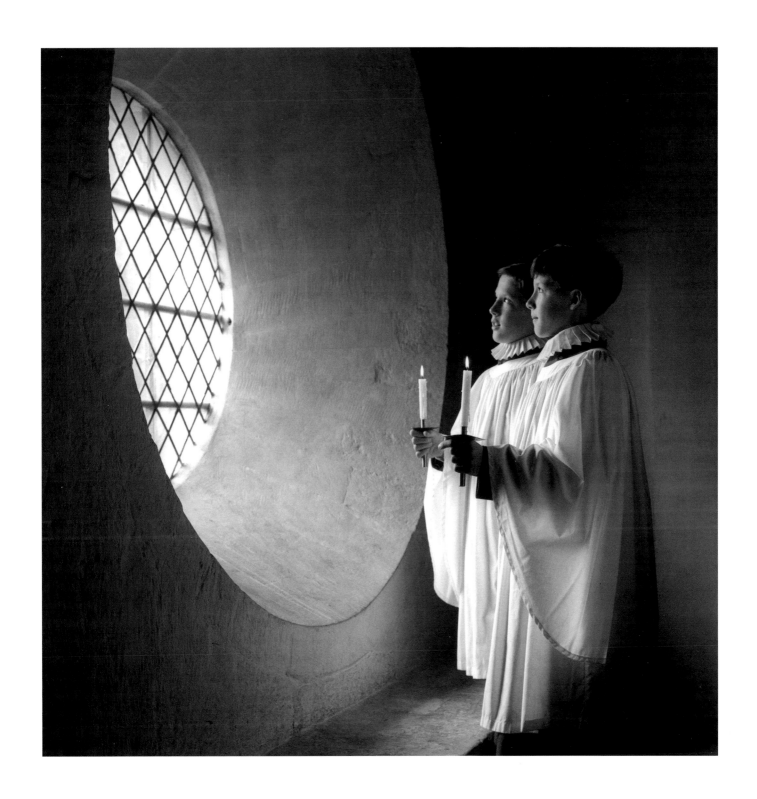

91
The twins
Mark Snowdon

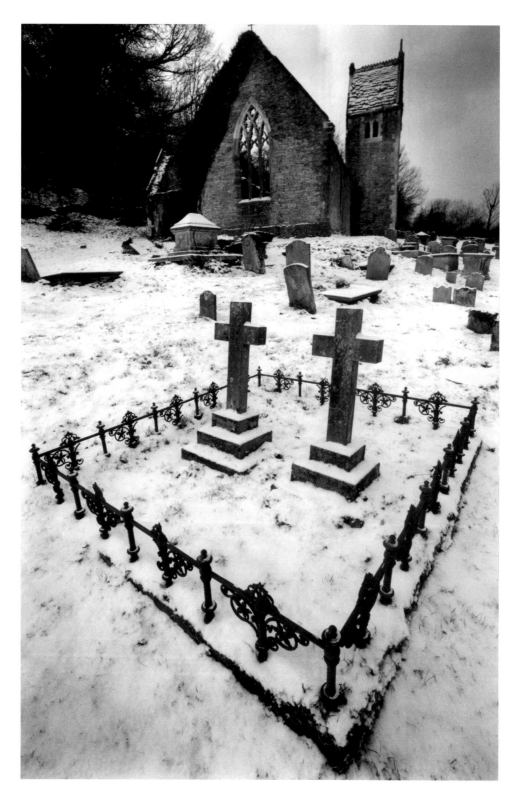

92
The forgotten
Jim Wild

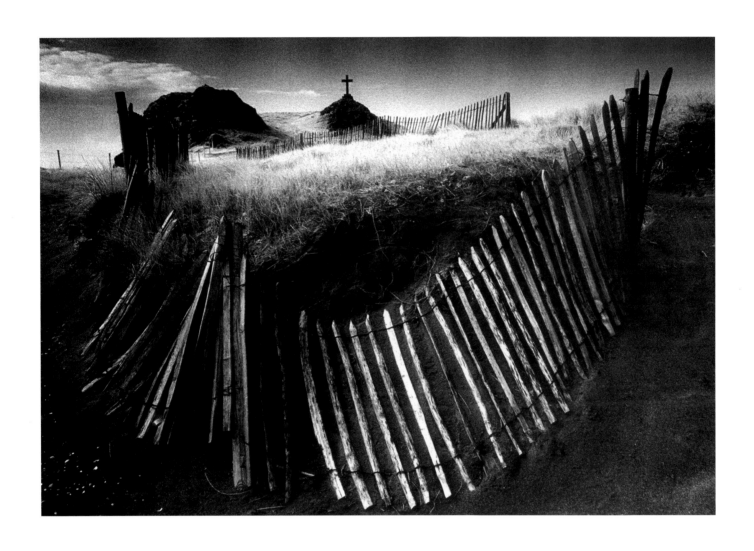

93
Abandoned cross
Gary Phillips

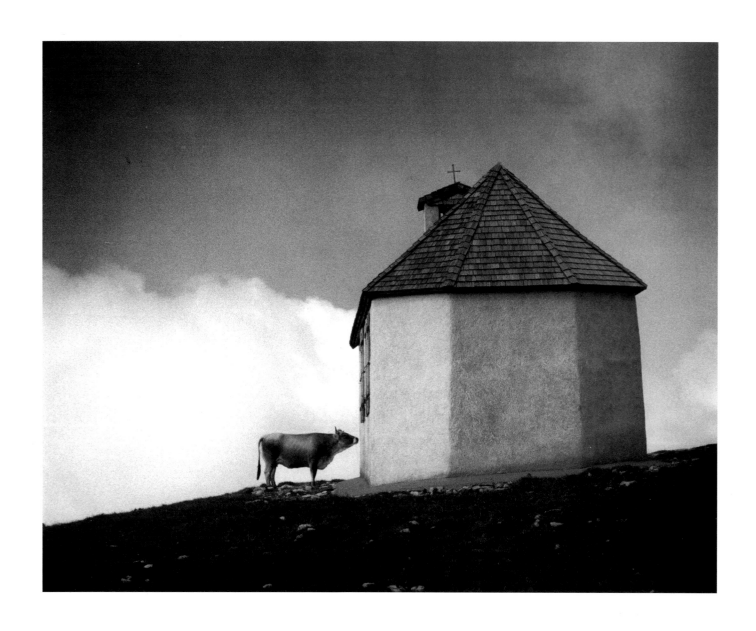

94
Holy cow
Malcolm Sales

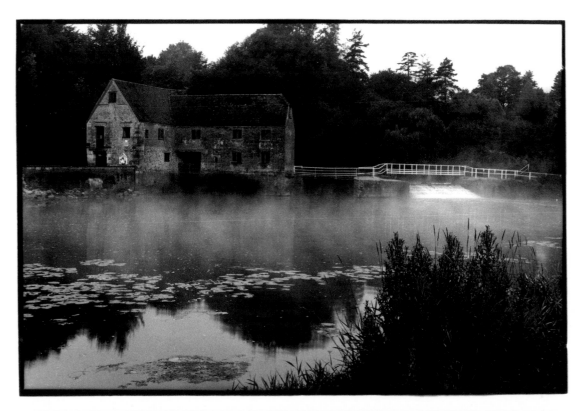

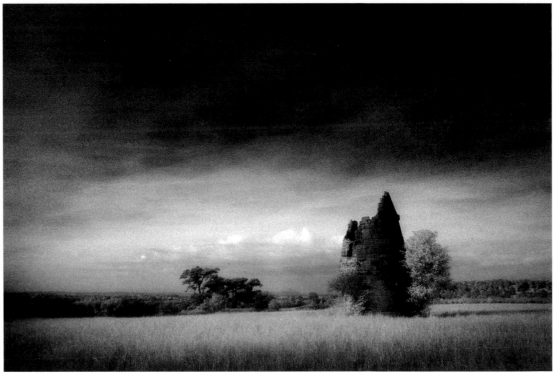

(top) 95 **The old mill at dawn** *Frederick Ellis*
(bottom) 96 **Derelict mill** *Alan Brown (Staffs)*

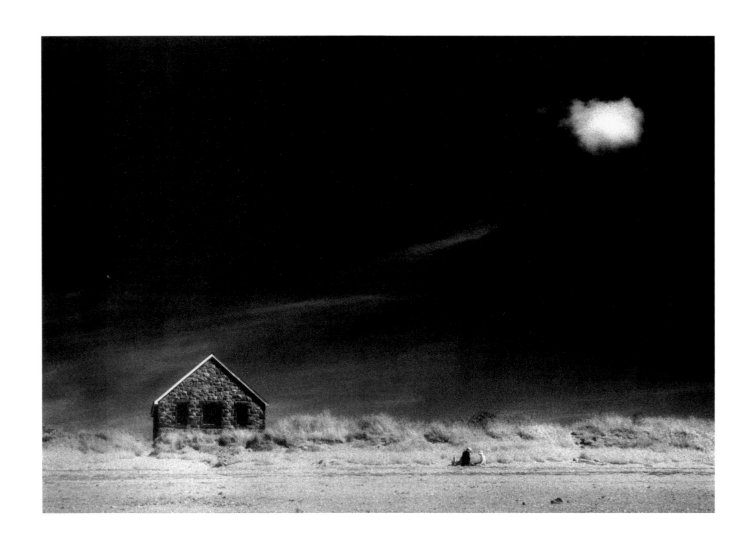

97
A passing cloud
Nick Duncan

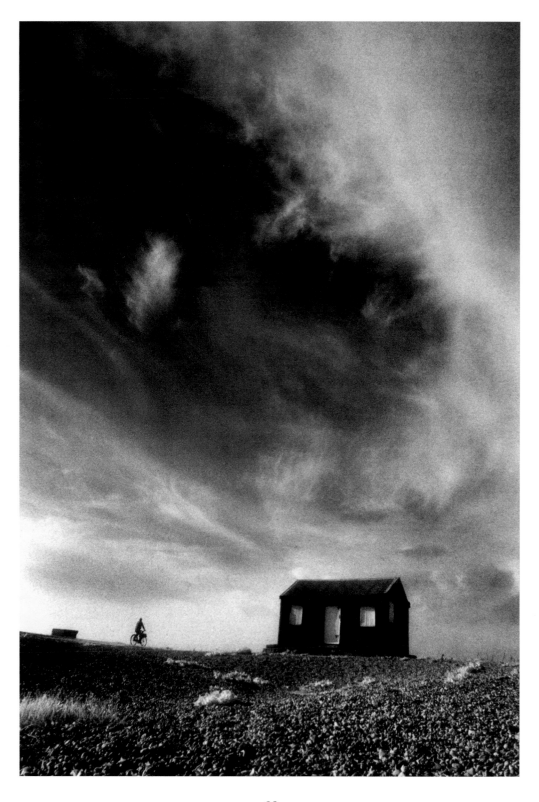

98
Black hut
Jeremy O'Keeffe

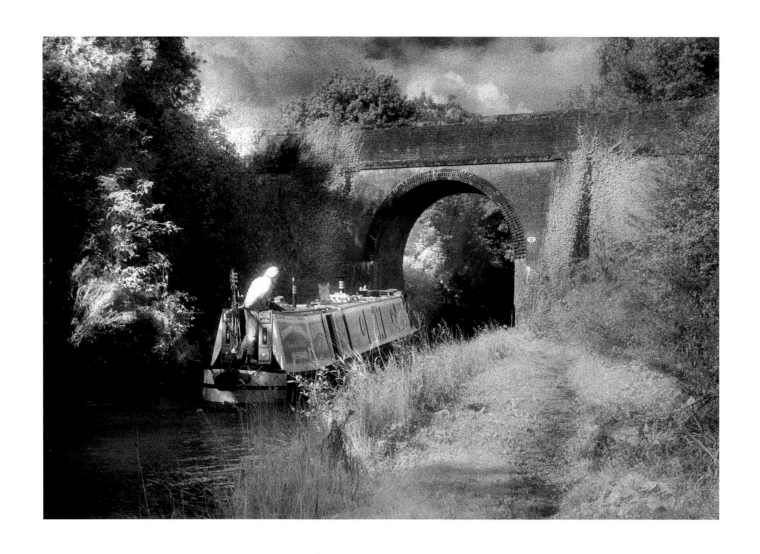

99
Tillerman
Peter Williams

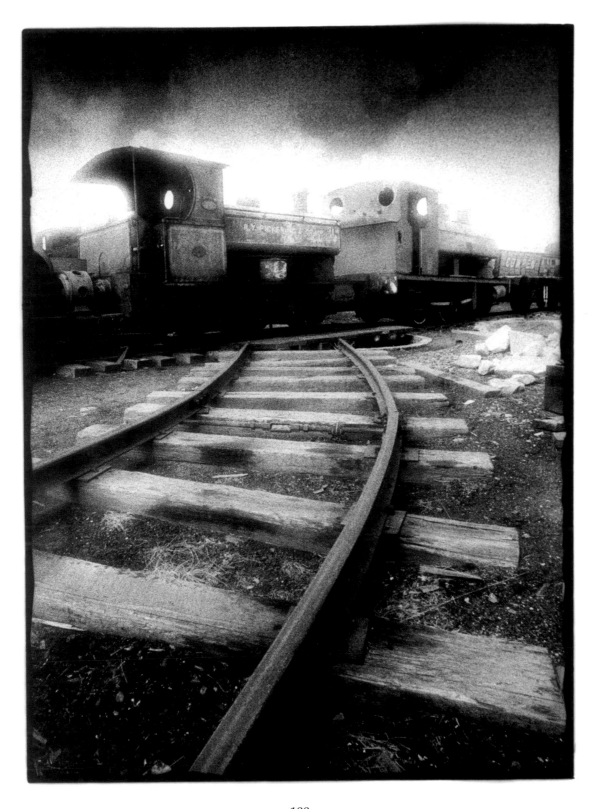

100
No title
Graeme Hunter

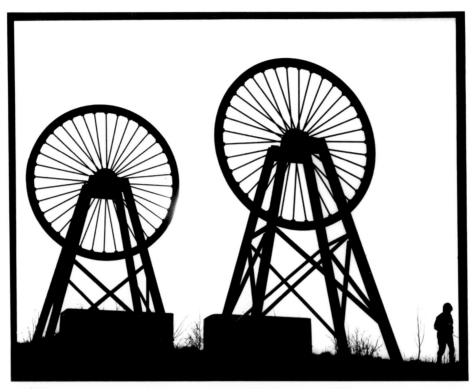

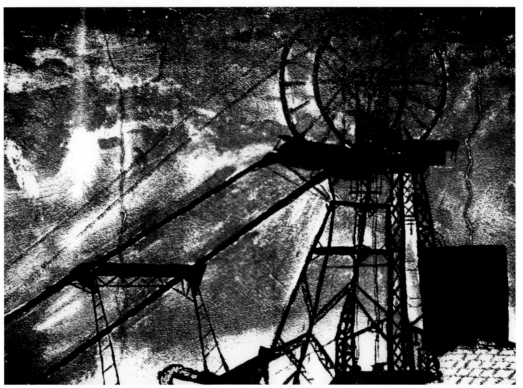

(top) 101 **Pit wheels** *Edward Jones*
(bottom) 102 **Black coal** *David Wilding*

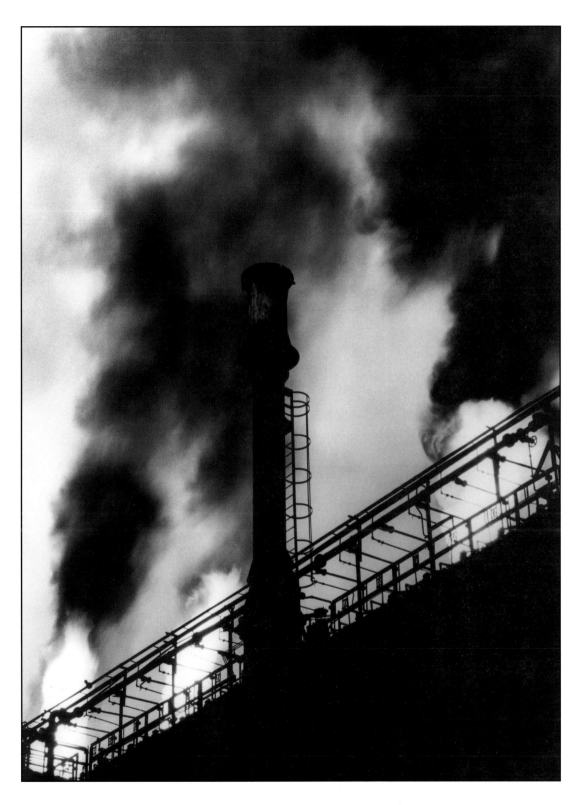

103
Cosipa – study 3
Bruno Caruso

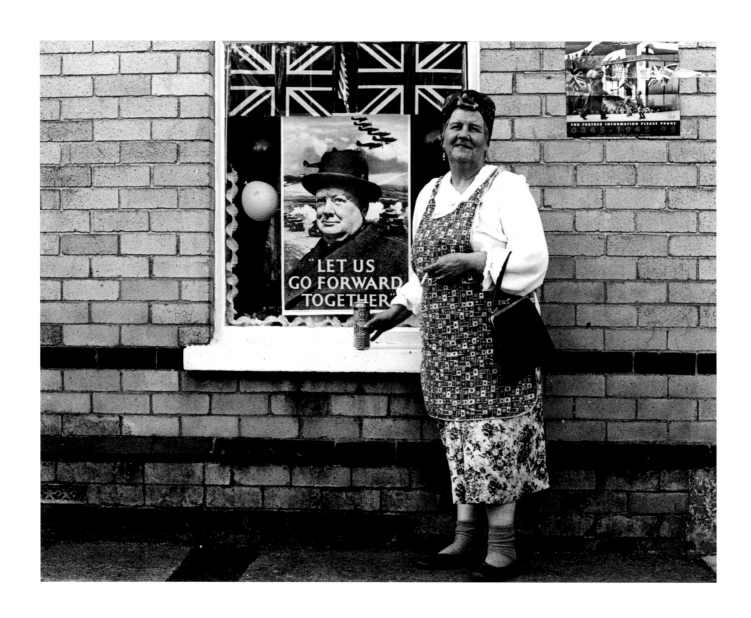

104
VE-Day '95
David Wilding

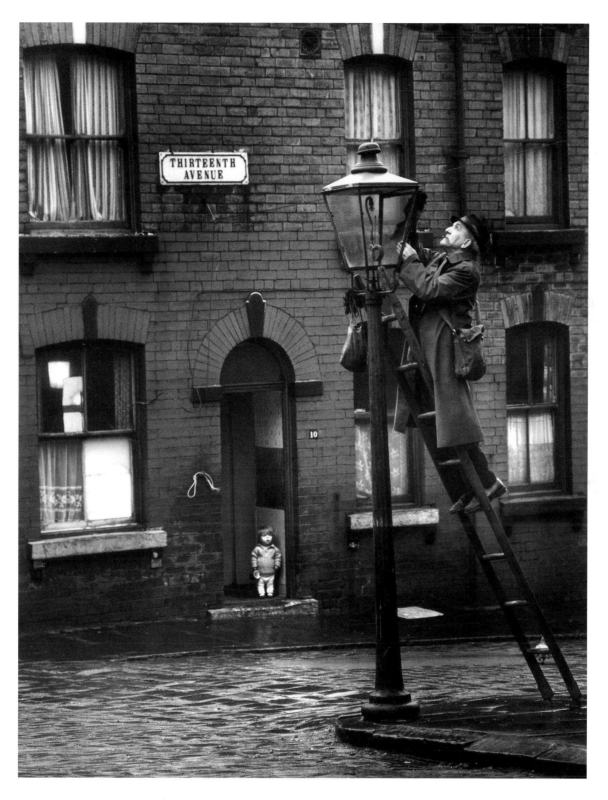

105
Thirteenth Avenue, Leeds
Bill Carden

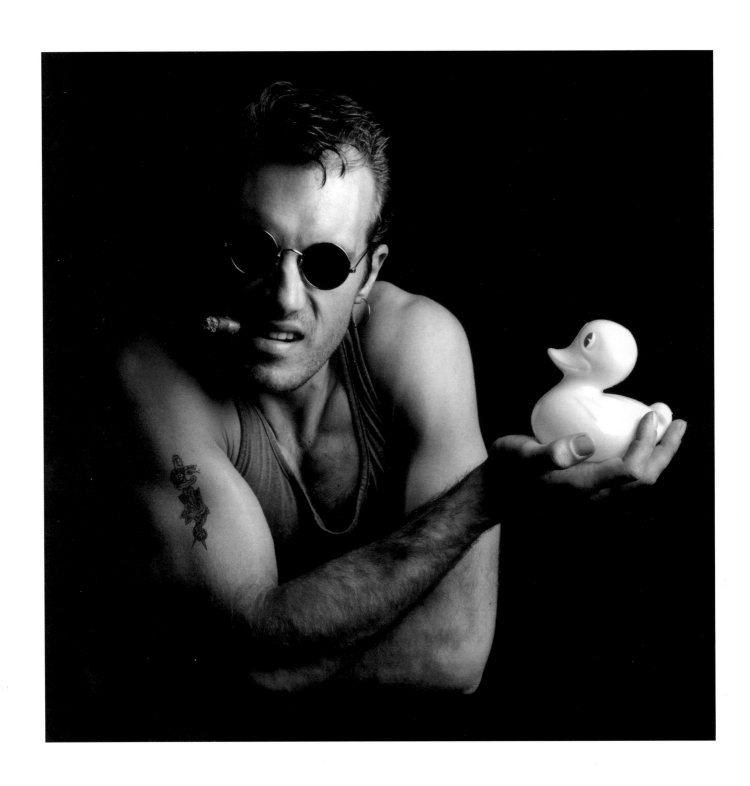

106
Duck
Trevor Legate

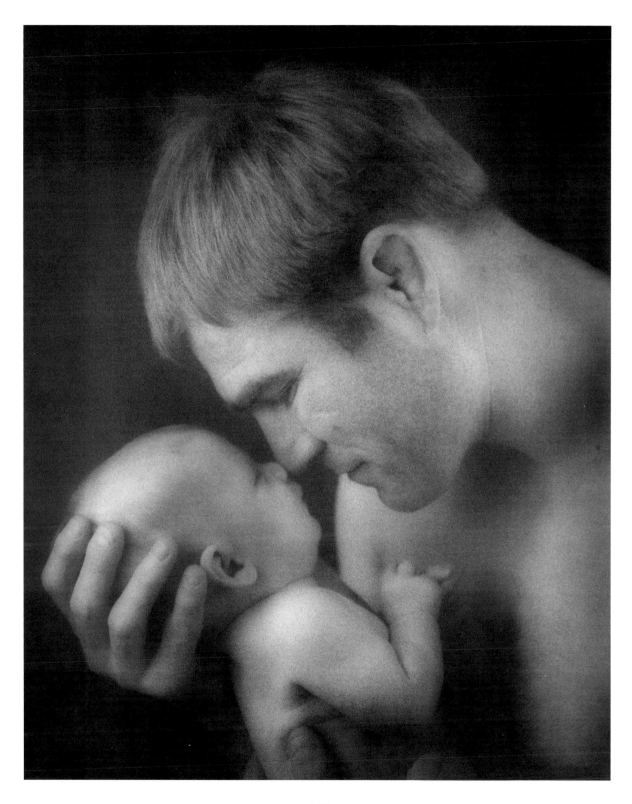

107
Belonging IV
Sue Davies

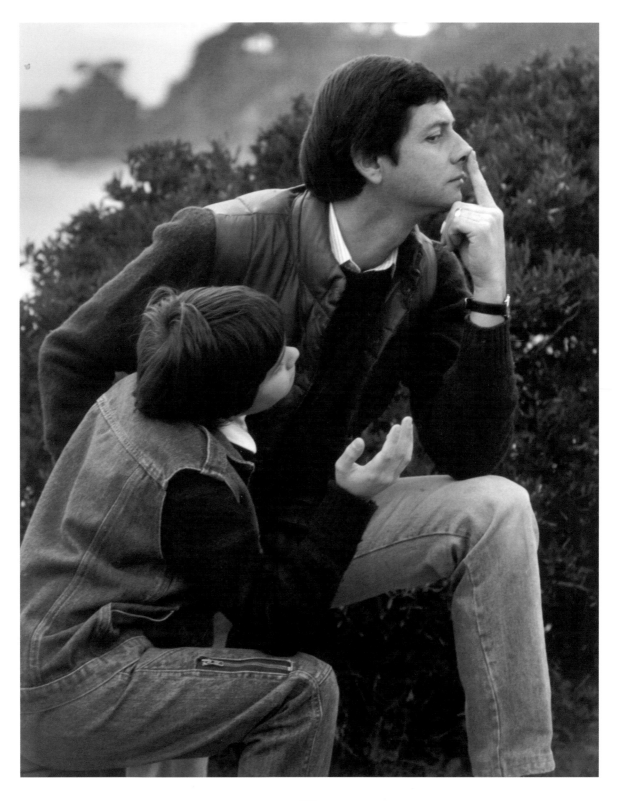

108
Please, dad
Peter Thoday

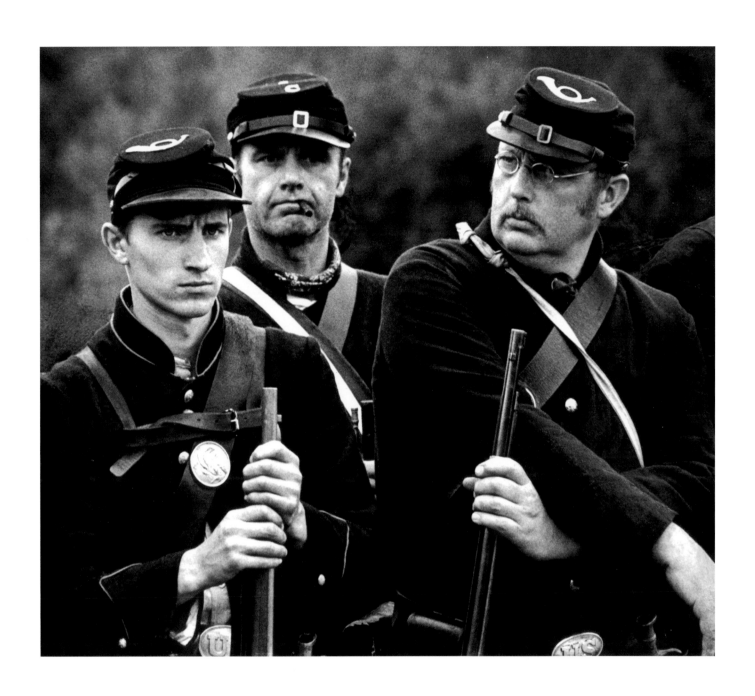

109
Union infantry at assembly
Hilary Fairclough

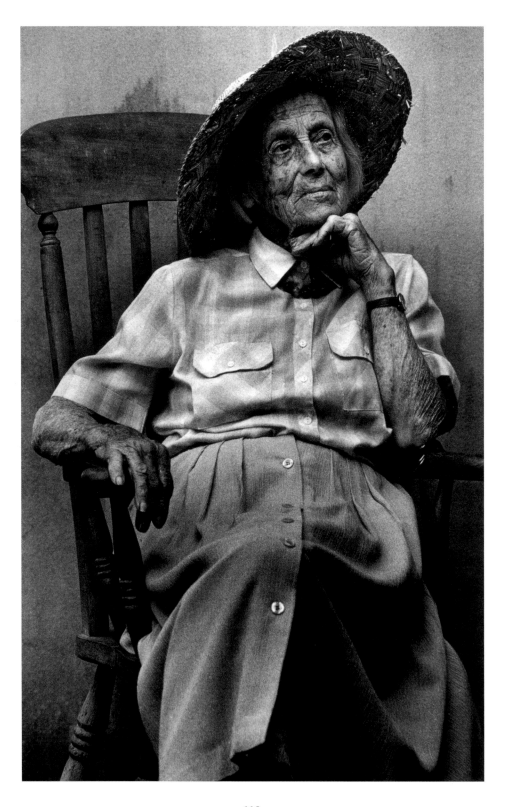

110
Jane
Trevor Jackson

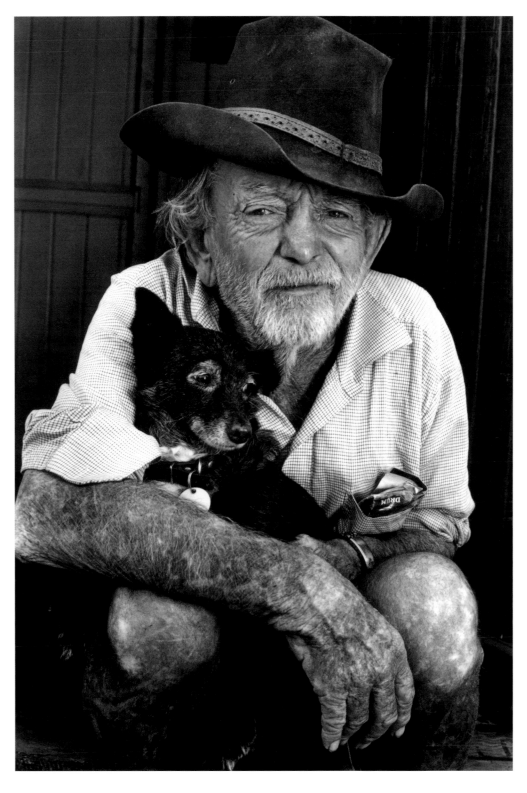

111
Pat Kelly
David Mahony

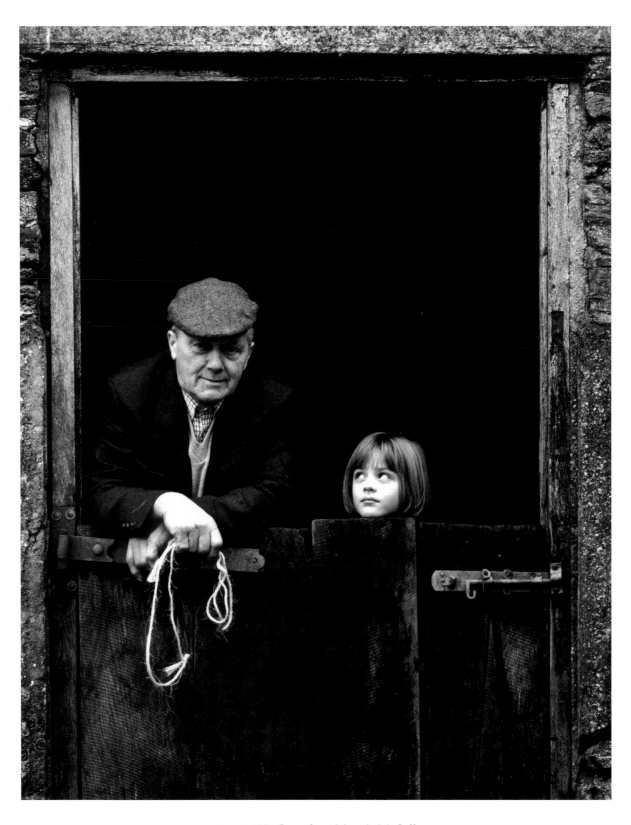

(above) 112 **Grandpa** *Maggie McCall*
(top right) 113 **Horse boy** *Des Clinton*
(bottom right) 114 **Ned** *Patrick Reilly*

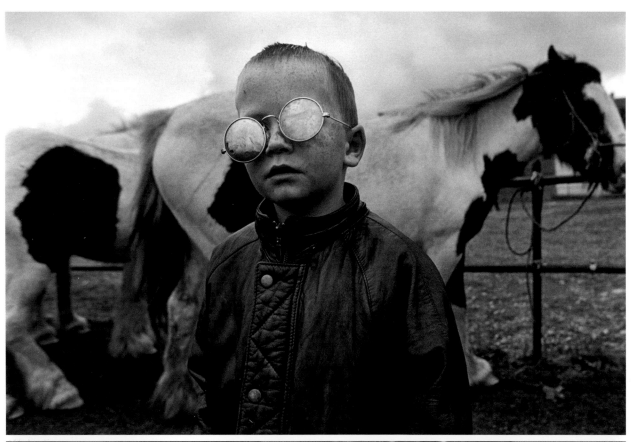

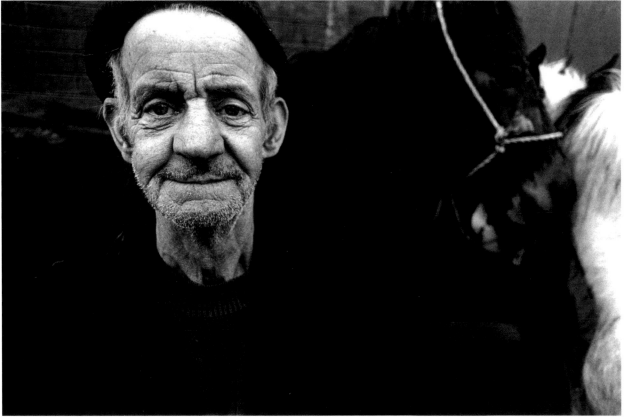

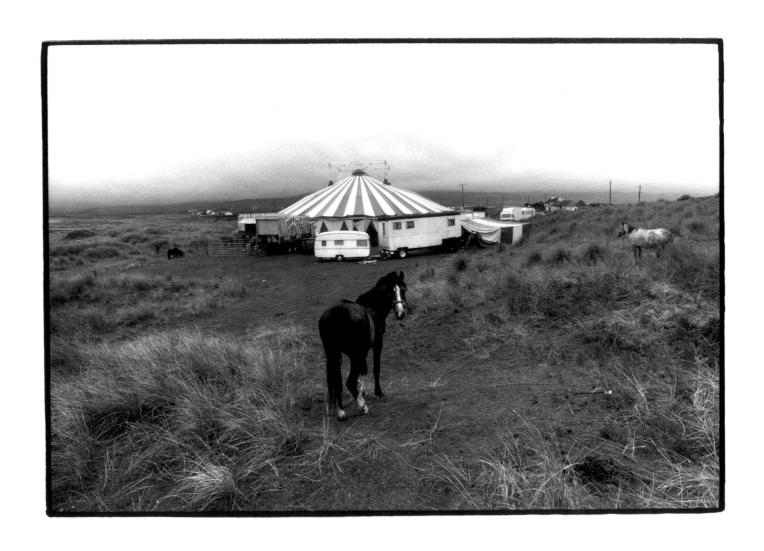

115
Circus
Klaus Peters

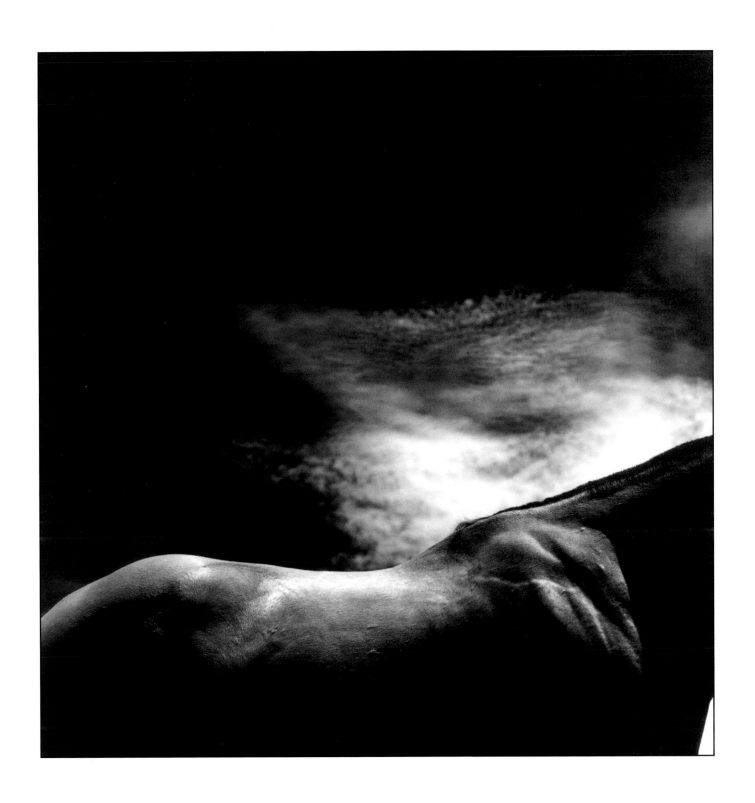

116
Winged horse
Roger Skinner

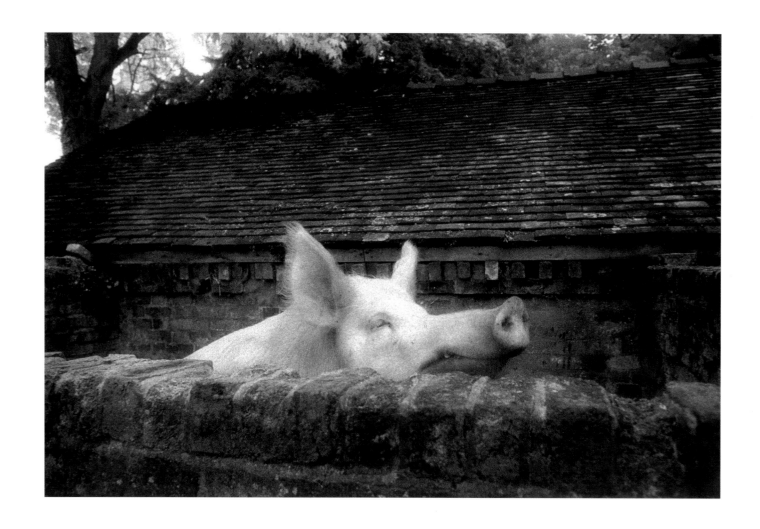

117
Pig at Acton Scott
Charles Baynon

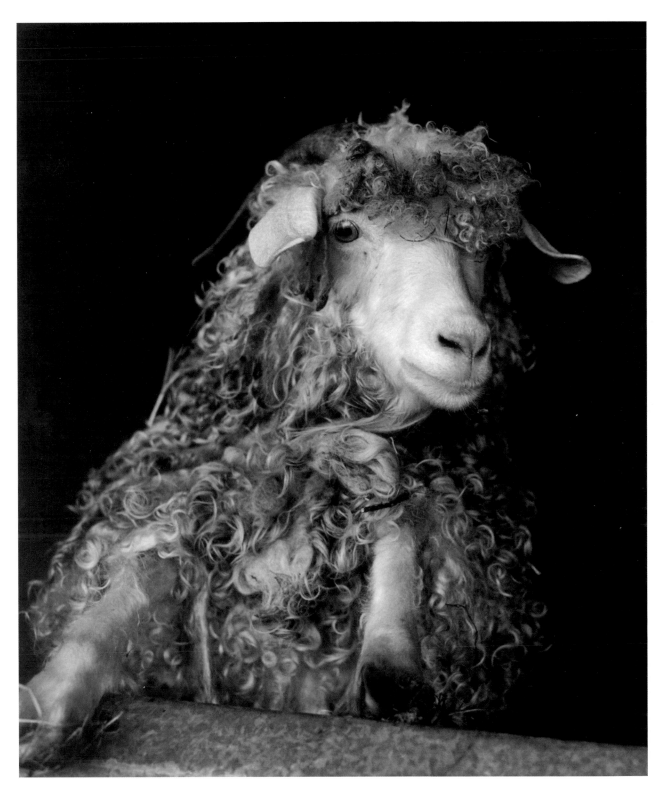

118
A sagacious sheep
*B**** Skinner*

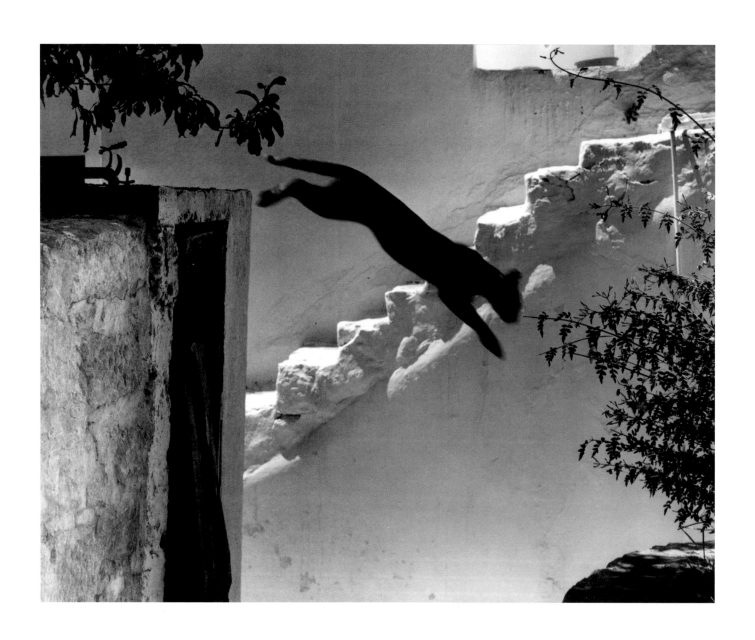

(above) 119 **Jumping** *R*** Milon*
(top right) 120 **No title** *Michael Milton*
(bottom right) 121 **No title** *Michael Milton*

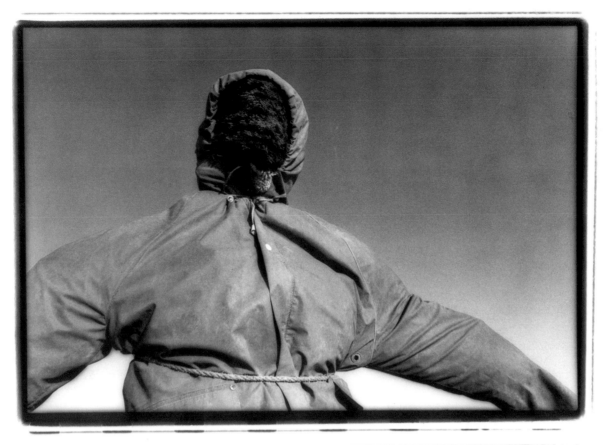

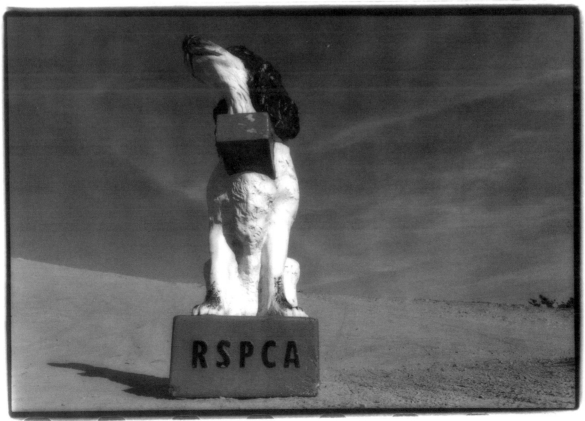

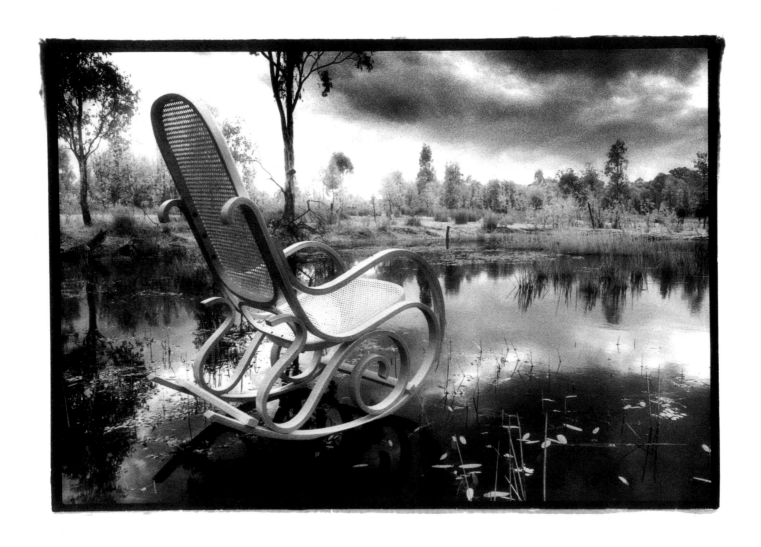

122
Rocking chair #1
Dawn Heath

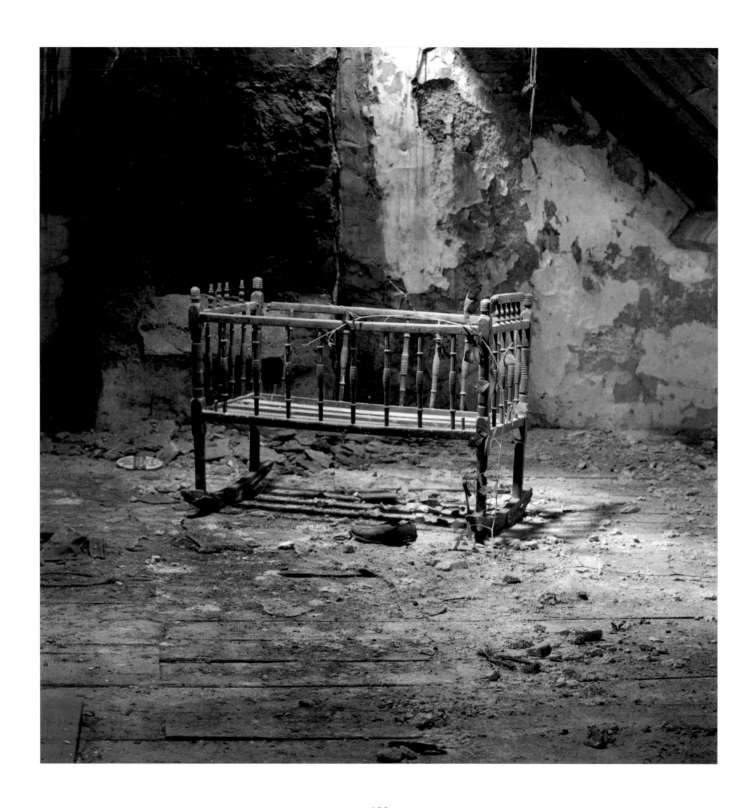

123
Childhood left
Keith Rolleston

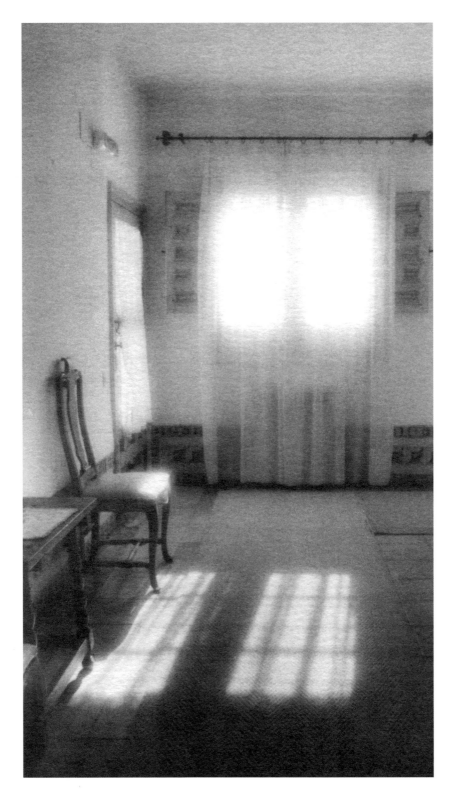

124
Morning sun
Carolyn Bross

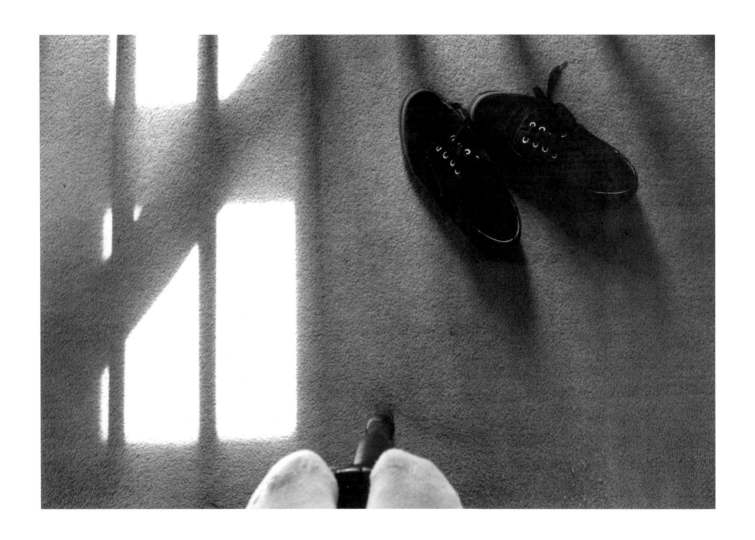

125
Black shoes
Robert Kirchstein

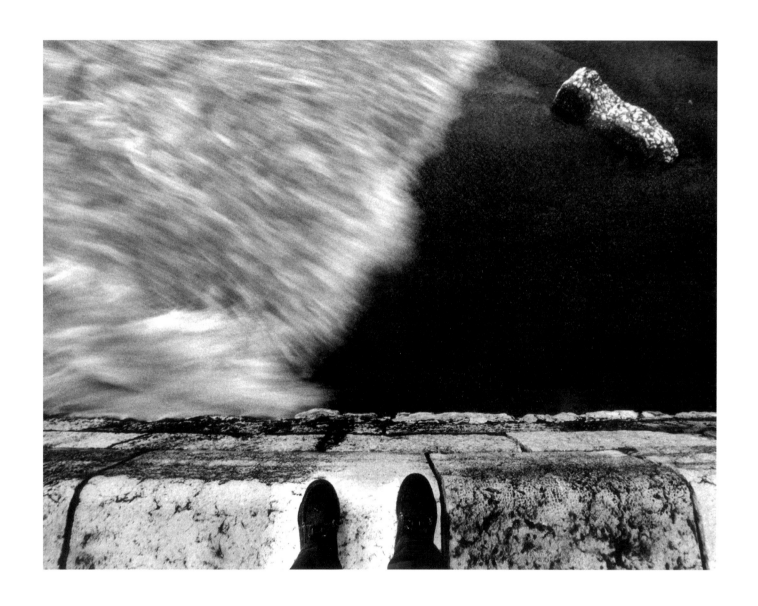

126
Crossing borders
Sérgio Leitão

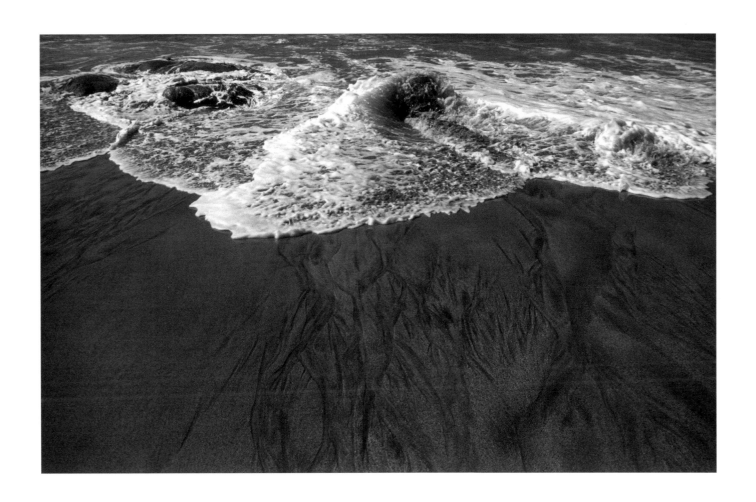

127
Breaking wave
Cliff Threadgold

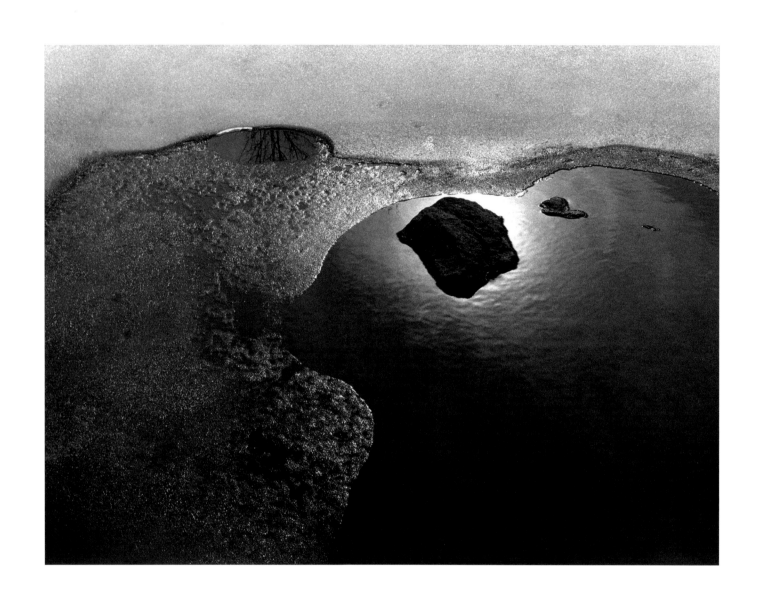

128
Rock eclipse
Len Perkis

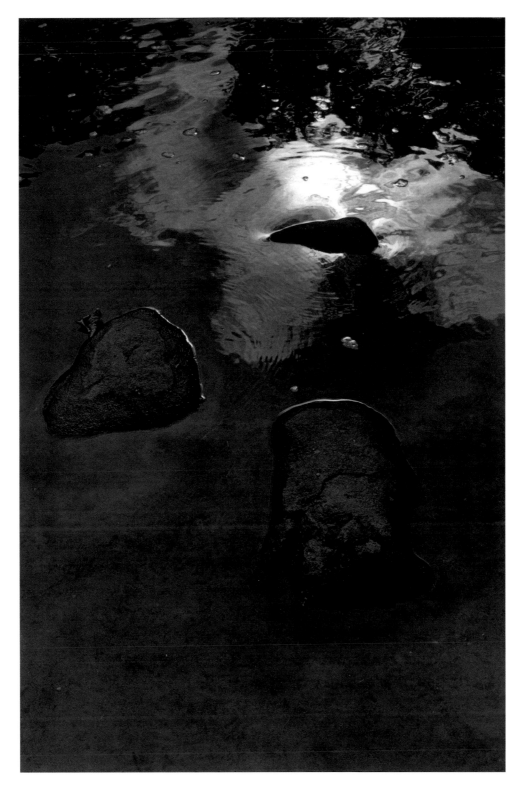

129
Dark water II
Malcolm Reed

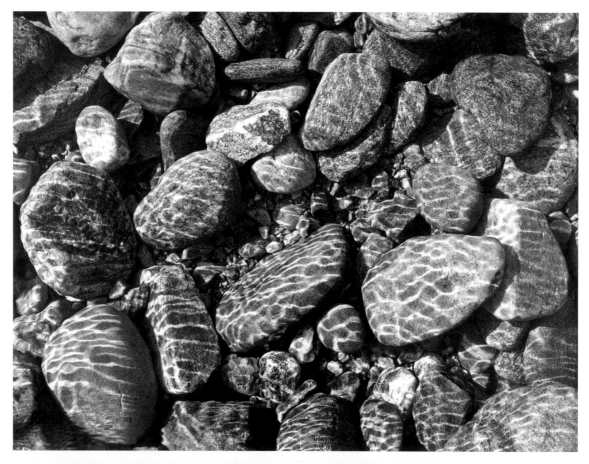

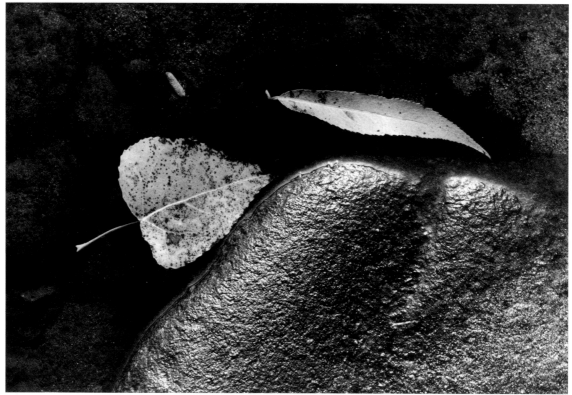

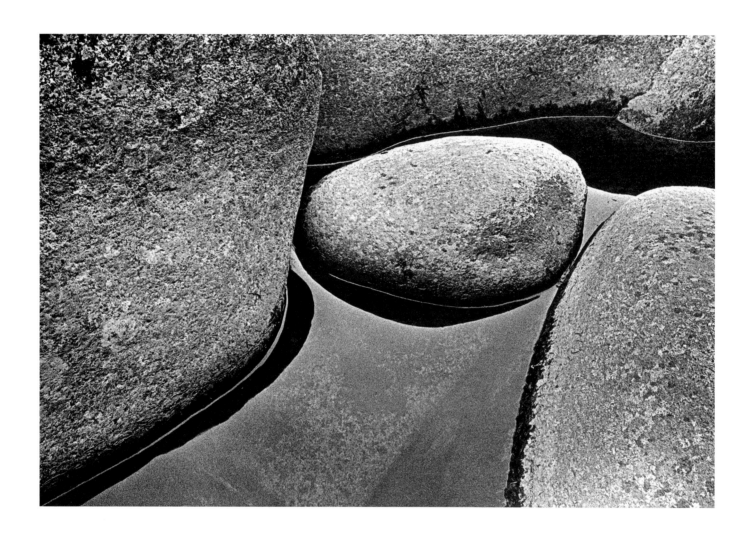

(top left) 130 **Pebbles in highland stream** *Jean Wheeler*
(bottom left) 131 **In a quieter current 2** *Hazel Sanderson*
(above) 132 **Stone and water** *Jiri Bartos*

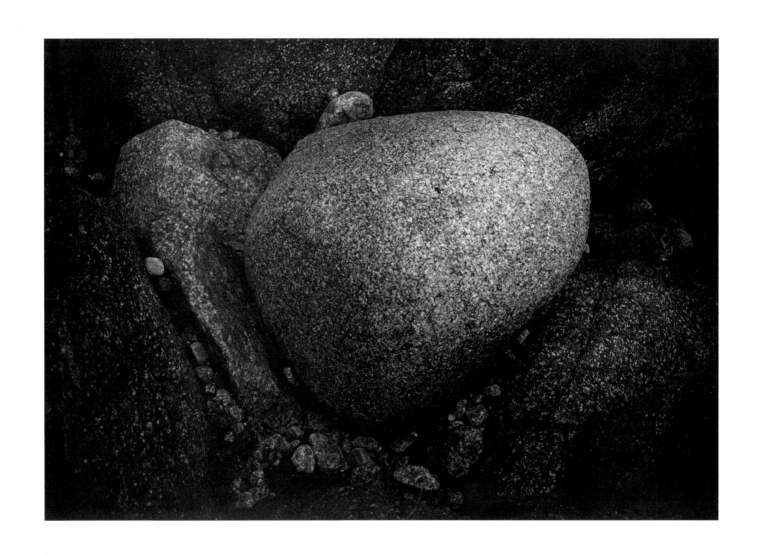

133
The rock
John Nasey

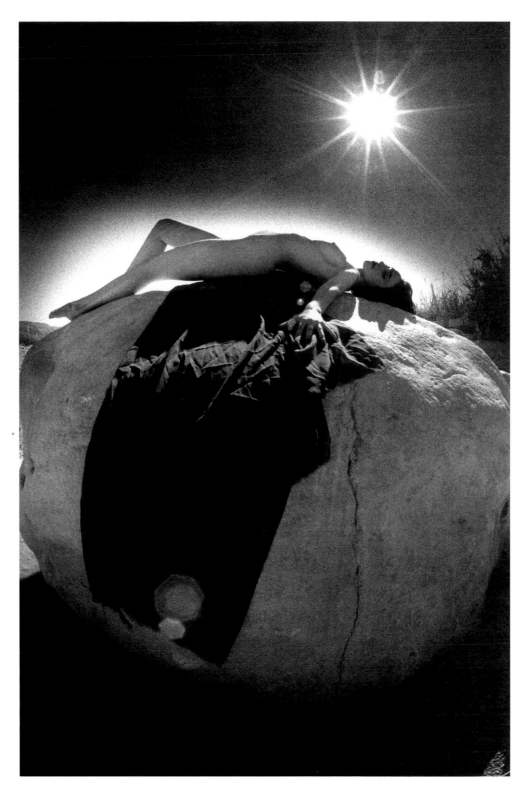

134
Sleeping beauty
David Aruety

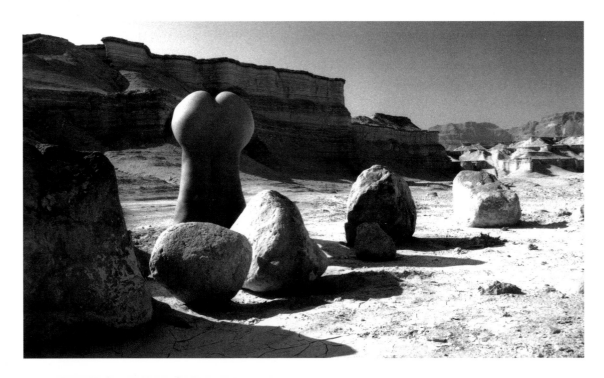

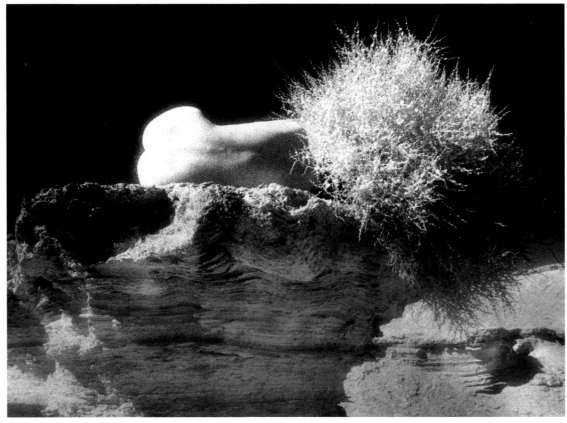

(top) 135 **Rocks and sandcastles I** *Ron Abrahams*
(bottom) 136 **Three shapes** *Ron Abrahams*

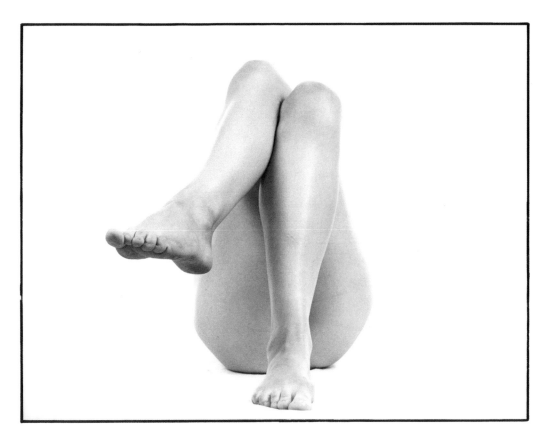

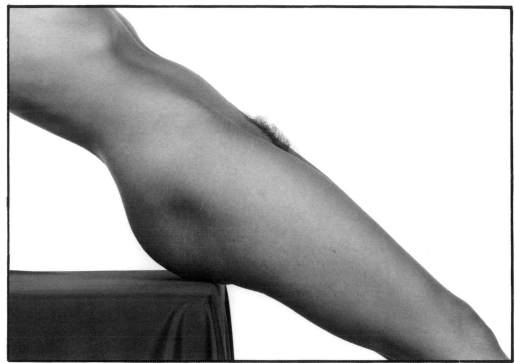

(top) 137 **Feet** *Andrew Foley*
(bottom) 138 **Reclining nude** *Andrew Foley*

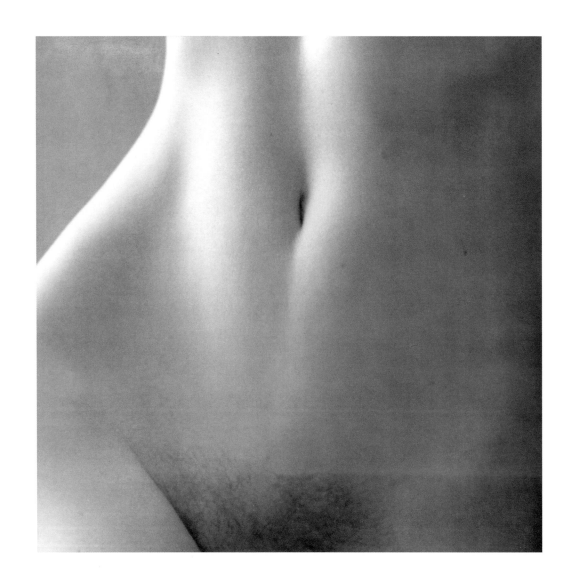

139
No title
Roy Elwood

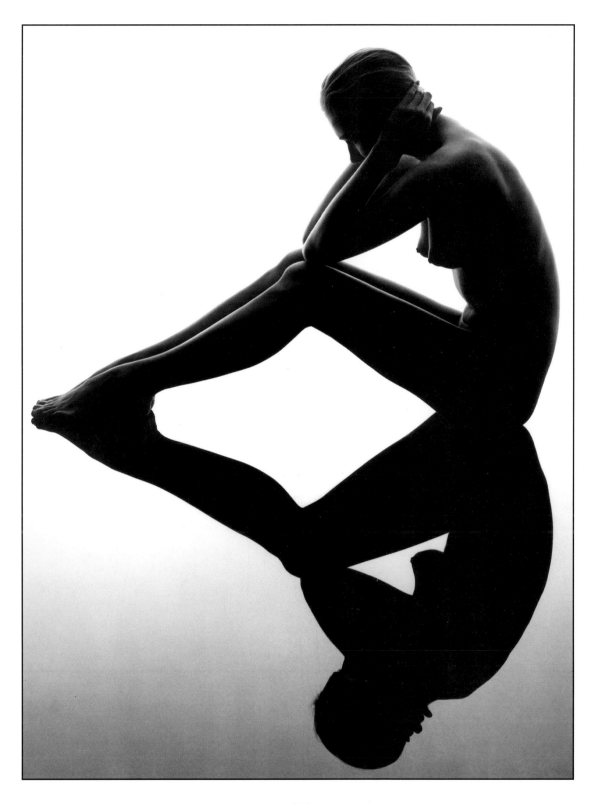

140
Reflection
Trevor Legate

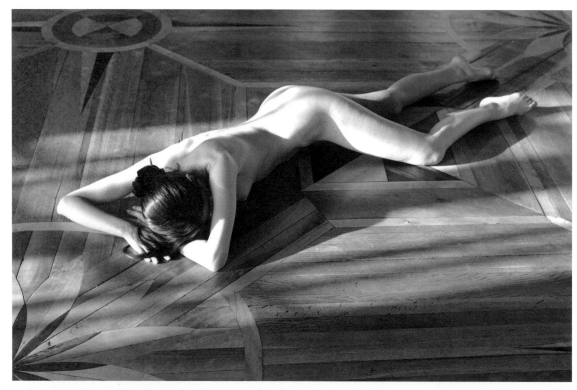

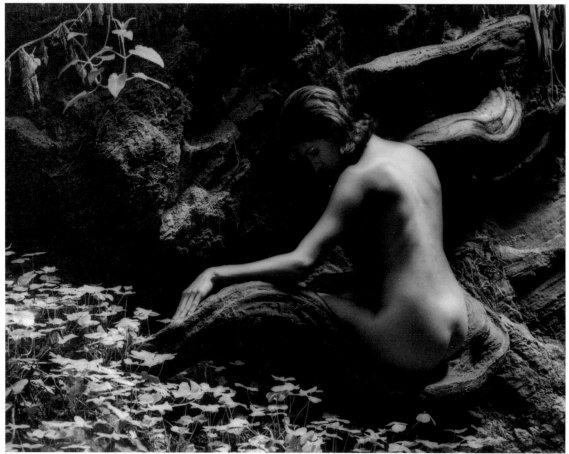

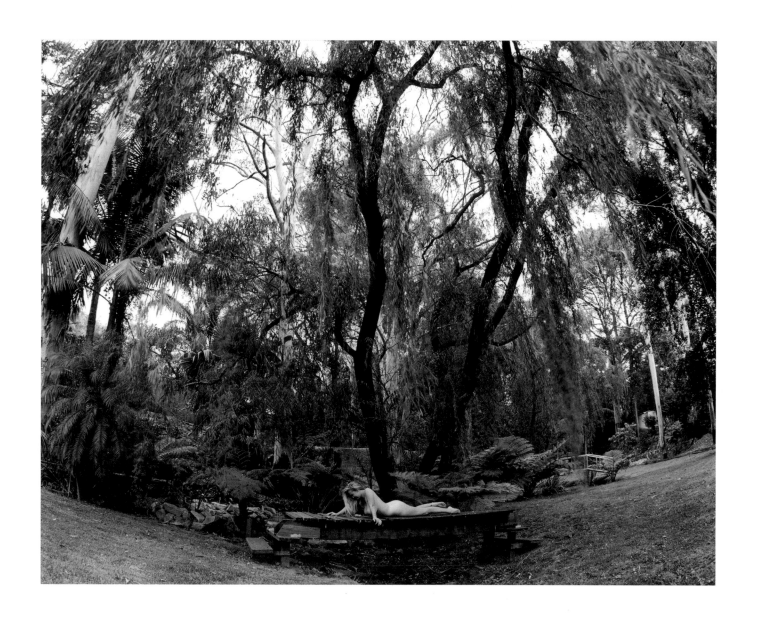

(top left) 141 **Floor nude** *Roy Elwood*
(bottom left) 142 **Classico** *Cameron Shaw*
(above) 143 **Brooke** *Corey Pavic*

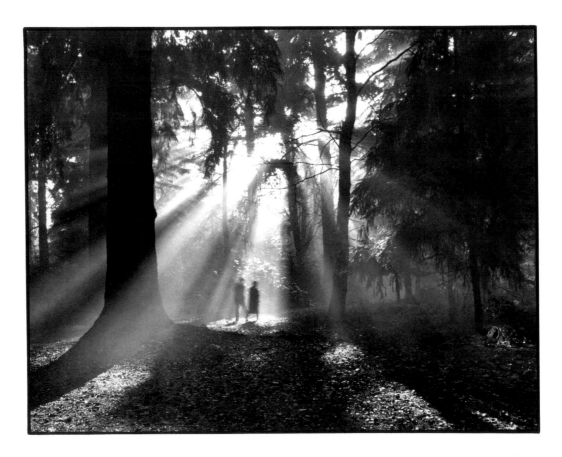

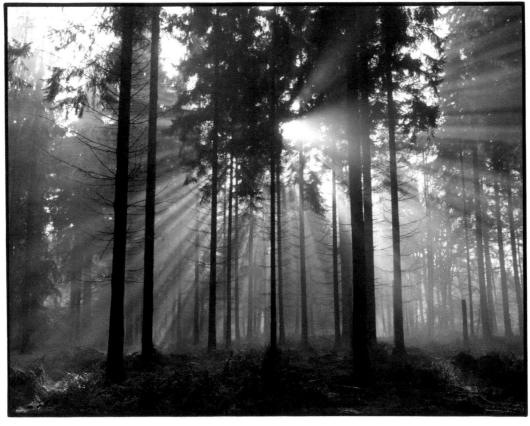

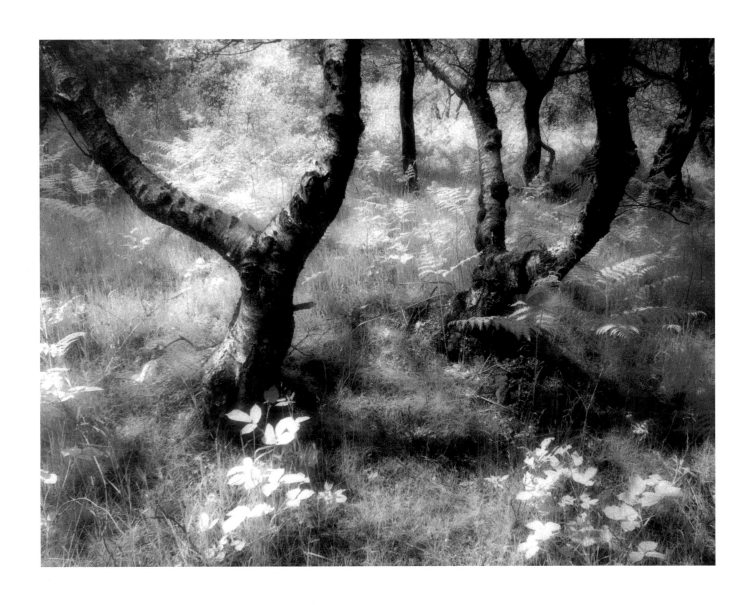

(top left) 144 **Visitors** *Kathleen Harcom*
(bottom left) 145 **Boldrewood** *Kathleen Harcom*
(above) 146 **Woodland scene** *Alan Brown (Staffs)*

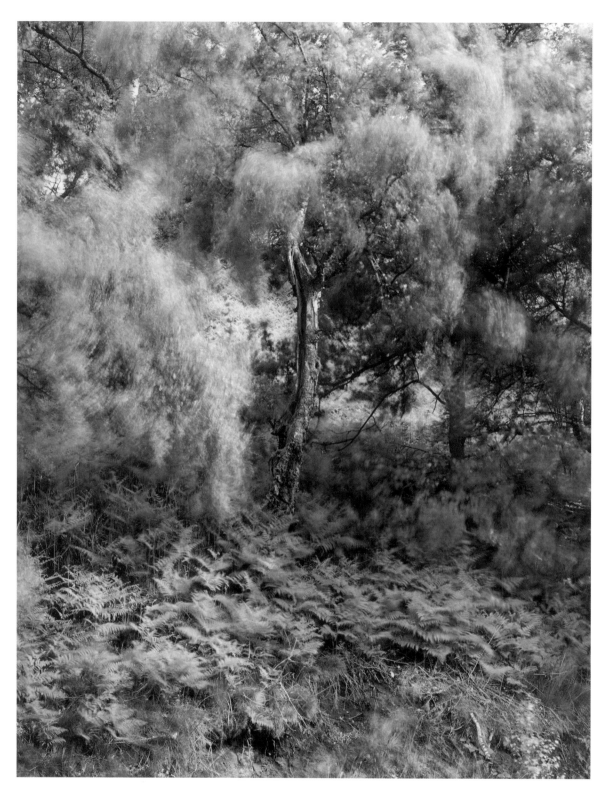

147
Windy day at Hollinhay Wood
Robert Kent

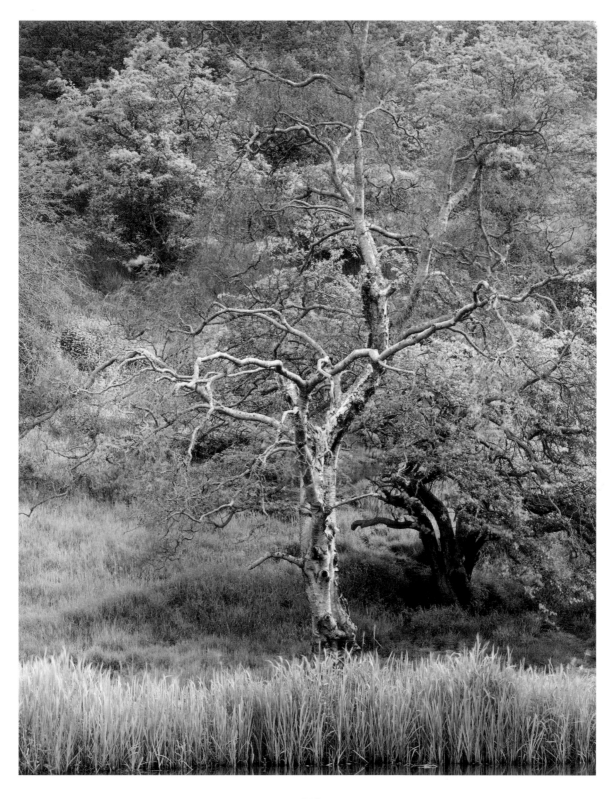

148
Tree of strife
Robert Kent

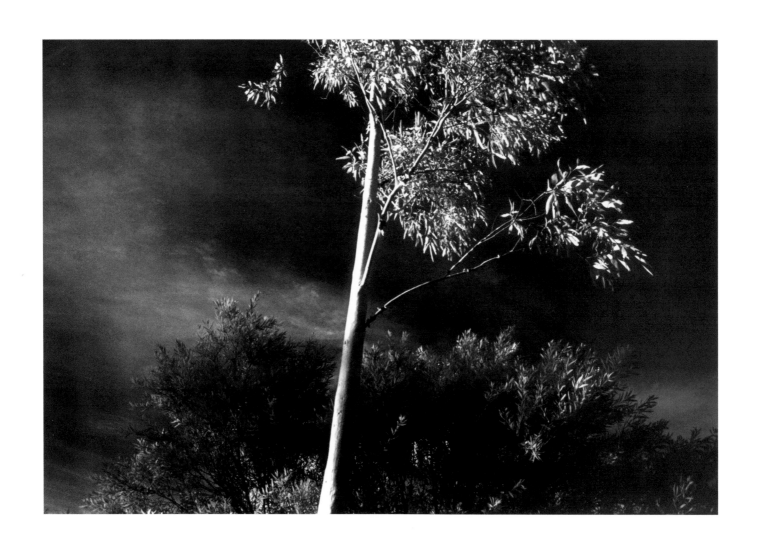

149
Maculata study II
Roger Skinner

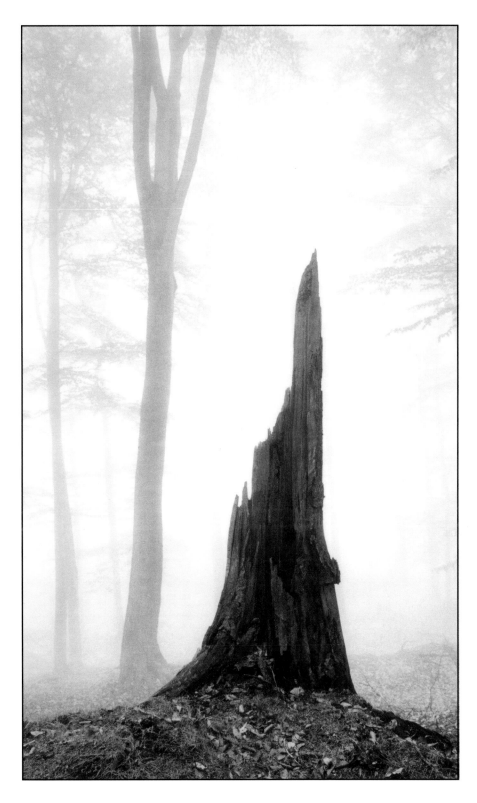

150
Fog in forest I
Jiri Bartos

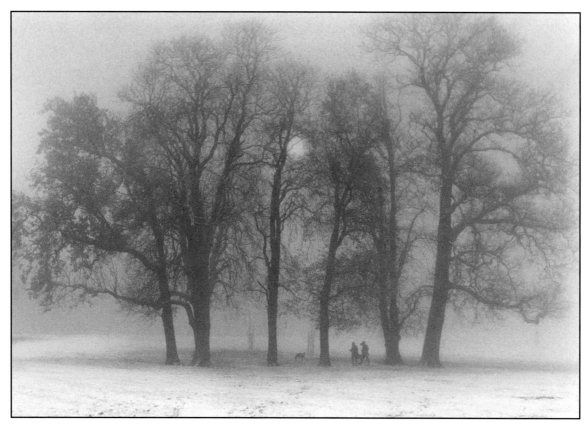

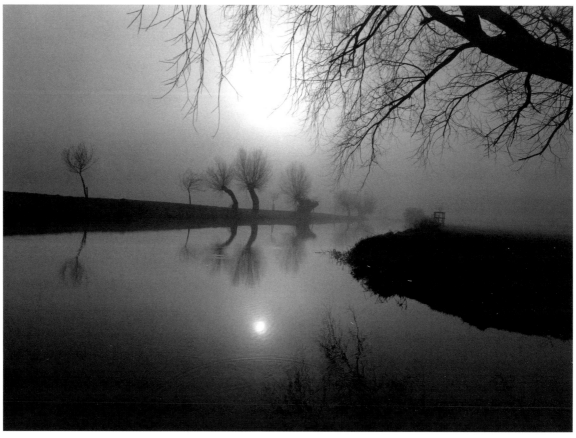

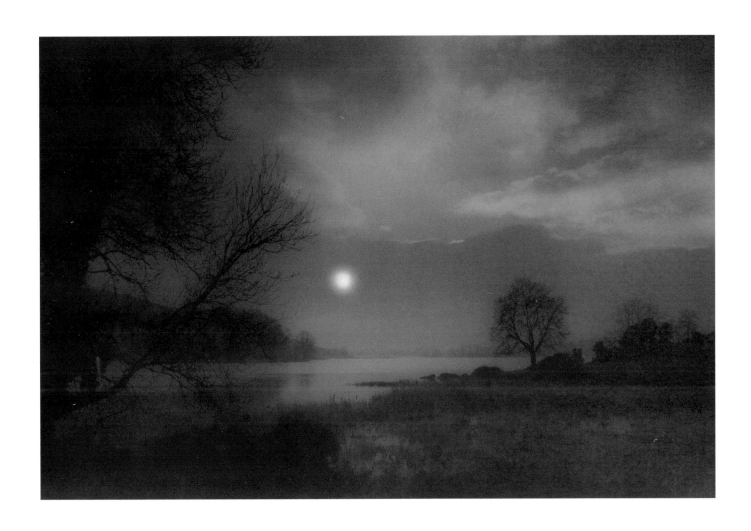

(top left) 151 **A winter's walk** *Brian Goad*
(bottom left) 152 **Grantchester Meadows** *Derek Langley*
(above) 153 **Winter evening at Lough Gur** *Pat Canavan*

Contributor profiles

The contributors are asked to supply brief background information on themselves and their photography, which forms the basis for the following edited profiles. The italicised numbers refer to the plate numbers (*not* the page numbers) of the photographers' images. There is a glossary of the main abbreviations used on page 144.

Mike Aamodt *(New Zealand)*
Mike has been making images for over 30 years, having been given a Kodak Vestpocket Hawkeye by his parents. A founder member (and now Trustee) of the New Zealand Centre for Photography, Mike's work is held in collections around the world and he is an avid collector of work by other photographers. *(22)*

Ron Abrahams *(Israel)*
A dental surgeon by profession, Ron has been active in photography for about 11 years. He works solely in monochrome and concentrates on landscapes and outdoor figure work. *(135, 136)*

David Aruety *(Israel)*
Having bought a Zorki camera and darkroom equipment at the age of 16, David mainly took family snaps until 1993, when he joined the Israel Photographic Art Society. He is now an active participant in national and international exhibitions. *(134)*

Nick Ayers *(Bristol)*
Early retirement about four years ago gave Nick the opportunity to take a serious interest in photography. A member of the Bristol PS, he divides his time between monochrome and creative slide photography. *(47)*

Jiri Bartos *(Czech Republic)*
Jiri took up photography in 1954 and since has had over 25 exhibitions in the Czech Republic, as well as participating in numerous international exhibitions. Working mainly in monochrome, Jiri's main subjects are landscape, detail and structure, architecture, nature and creative photography. *(72, 132, 150)*

Charles Baynon *(Shropshire)*
A professional photographer for 13 years, Charles has recently opened an art gallery, where he sells his own photography as well as work by other artists in a variety of media. His main subject interests are landscape, still life and the nude. *(77, 117)*

Neil Bedwell *(Lancashire)*
Neil originally became interested in photography as an aid to painting and drawing. However, a night school class showed him the creative potential of darkroom work, and he now prefers photography as a means of image-making. His aim is to convey atmosphere rather than make detailed records of his subjects. *(73)*

Denis Bourg *(London)*
Denis describes his objective as "to enlighten the hearts and minds of the people through showing the extraordinary within the ordinary; the beauty within the mundane". He discovered monochrome infra-red photography in the early 1990s and this has become his favoured and most successful medium. *(70)*

Kevin Bridgwood *(Staffordshire)*
At the age of 7, Kevin took a camera on a school day trip, took snaps of the other kids and then attempted to sell them his results. He didn't make many sales, but loved taking the photos, so continued to take snaps for the fun of it – "and still do". *(59, 60)*

Carolyn Bross *(USA)*
Her husband's Valentine's Day gift of a camera in 1985 started Carolyn's romance with photography and the path to a new career. Her monochrome images are often selectively hand-coloured to reflect her emotional response to the subject and these have been widely exhibited and published. *(124)*

Alan Brown *(Staffordshire)*
Although only becoming interested in photography in 1988, Alan has had numerous acceptances in national and international salons and holds distinctions of the PAGB and BPE. He is a member of the highly active Moorland Monochrome Group. *(96, 146)*

Alan Brown *(Tyne & Wear)*
Though known to turn his camera to most subjects, Alan's photographic preference is sport, which he feels is too often dismissed as offering little opportunity for creative work. He has been a member of South Shields PS since taking up photography in 1990. *(51)*

Mike Calder (Australia)
A recent convert to monochrome photography, Mike enjoys using infra-red film. An Associate of the APS, he has produced a book of monochrome photographs and has had his work published in magazines. (65)

Pat Canavan (Ireland)
Pat came to photography through his interest in drawing and painting, and has now found photography to be his favoured medium. Access to a darkroom has opened a whole new world of expression in his landscape, still life and portraiture work. (88, 153)

Michael Cant (Essex)
Inspired by the Christmas gift of Best of Friends 3, Michael has returned to photography after several years away. His future plans include building a portfolio of monochrome pictures taken around Essex churches. (84)

Bill Carden (Middlesex)
A member of High Wycombe CC and the London Salon, Bill gained his RPS Fellowship in 1971 and has served on the Pictorial and Licentiateship distinction panels. He is a member of the RPS distinctions advisory board. He is best known for his candid photography of people. (105)

Bruno Caruso (Brazil)
Bruno has been taking photographs for over 20 years, carrying his Leica with him everyday, usually loaded with black and white film. A member of PhotoGraphus club, he has taken part in several exhibitions in Brazil. (103)

Christine Chambers (Surrey)
This is Christine's third consecutive appearance in Best of Friends. She continues to experiment with graphic ideas, as well as enjoying landscape and still life work. She is a member of Selsdon CC and an RPS Associate. (27)

Peter Clark (Staffordshire)
A member of Cannock PS and a Fellow of the RPS, Peter is a well known judge and lecturer. He has achieved over 950 exhibition acceptances, including around 150 awards. He holds the Excellence distinction of FIAP. (55)

Richard Clegg (Cornwall)
Inspired by the high standards set in club photography, Richard gained his Licentiateship of the RPS in 1993 and has had work accepted in national and international exhibitions. His recent move to Cornwall has provided an overwhelming array of potential subjects. (17)

Des Clinton (Ireland)
Des started photography over 30 years ago and enjoys meeting fellow photographers and looking at their work. His favourite subjects are people and the landscape. (113)

Garry Corbett (West Midlands)
No profile available. (29)

David Couldwell (South Yorkshire)
When David joined Doncaster CC two years ago, he was amazed by the potential of monochrome and promptly set about making a darkroom in his home. He has now progressed to the intermediate section at the club. If selection to Best of Friends is anything to go by, he won't be there for long! (90)

Trevor Crone (London)
Trevor has had more images published in the Best of Friends series than any other photographer. His work has been exhibited and published widely. He has recently had a personal perspective of Kent published by Creative Monochrome as The Intimate Garden. (46, 75)

Steven Cull (Cornwall)
Steven has been taking photographs seriously for about 10 years and has recently started submitting work to national salons "with some success and some disappointment". He particularly enjoys photography of nearby beaches and portraiture. (42)

Paul Damen (Norfolk)
Paul, who holds a degree in photographic media studies, is an Associate of the BIPP and the RPS and a member of UPP. He is well known as a judge and as a tutor on photography. He has presented two videos on landscape photography techniques. (2, 7)

Sue Davies (Buckinghamshire)
Sue became hooked on photography as a result of enrolling on a City & Guilds modular photography course. Her work, for which she readily acknowledges the influence of John Blakemore, has been widely exhibited. Sue is an Associate of the RPS. (23, 107)

Corey Davis (Australia)
Now 24 years old, Corey has been involved with photography – primarily black and white – for 5 years. He works for a local professional photographer and a sports paper. He has just embarked on a course leading to a Diploma in Photography. (143)

John Devenport (Kent)
A member of the Mirage Group, Beckenham PS and Ashford CC, John works in both mono and colour. Primarily a landscape worker, he gained his Associateship of the RPS in 1988 and is a regular contributor to international exhibitions. (53)

Willie Dillon (Ireland)
A member of Drogheda PC, Willie has been taking black and white photographs for about 10 years. Many of his images are of women – distinctive portraits or more abstract creations involving the female form. (35, 36)

Nick Duncan *(Kent)*
Nick's work covers pictorial and landscape photography, and more recently portraiture, where he has been inspired by David Penprase and others. A member of Bromley CC, he is also an Associate of the RPS. *(32, 33, 48, 97)*

Brian Ebbage *(Norfolk)*
An enthusiastic club photographer for 18 years, Brian gained the Fellowship of the RPS in 1991 with a portfolio of monochrome landscapes. Enjoying the unreality and atmosphere of black and white, Brian's subject interests include landscape, nudes and infrared photography. *(64)*

Frederick Ellis *(Dorset)*
Since retiring, Frederick has been able to devote more time to his lifetime enthusiasm for photography. Seven years ago he formed a camera club in his village, but he finds little interest there in monochrome – so he has found the Friends network a welcome inspiration. *(95)*

Roy Elwood *(Tyne & Wear)*
Roy prefers to work in themes – currently water, nudes and dancers – rather than individual images. He gained his Fellowship of the RPS with a panel of 20 nudes, each featuring parts of the male and female body. *(139, 141)*

Hilary Fairclough *(Lancashire)*
Finding it a more expressive medium, Hilary now works mainly in monochrome. She likes the challenge of capturing 'that special moment'. The syllabus secretary of Wigan PS, she holds the Licentiateship of the RPS. *(109)*

John Fairclough *(Lancashire)*
John is also an active member of Wigan PS and also primarily works in monochrome, where the thrill of seeing the latent image develop has never left him. His main subjects are landscape and people. *(40)*

John Fenn *(Suffolk)*
John returned to photography about 15 years ago and has learned much from participation in workshops at Inversnaid Photography Centre. A solicitor by profession, specialising in criminal work, John is convinced that his empty people-less landscapes are a reaction to the people he deals with in the 'day-job'. *(61, 62)*

Mark Fohl *(USA)*
Mark has been a serious amateur photographer for about 25 years, working almost exclusively in monochrome, but in a variety of formats. He has been involved with local camera clubs and the PSA. *(56)*

Andrew Foley *(South Yorkshire)*
Andrew has been involved in photography since 1989. He is a member of Mexborough PS and Gamma Photoforum, as well as an Associate of the RPS. His work has been exhibited in national and international salons. *(137, 138)*

Neil Gibson *(Cleveland)*
Neil has developed an abstract style of monochrome imagery, using 35mm to avoid preoccupation with photographic detail at the expense of content and meaning in an image. He takes an experimental approach to printing, involving softening, split-toning and, recently, the use of photograms. *(79)*

Brian Goad *(Suffolk)*
Brian's interest in photography became a passion about seven years ago, when he started his own processing and printing. His main interest is in landscape work. An active member of Ipswich and District PS, he holds the Licentiateship of the RPS. *(151)*

Edward Gordon *(Surrey)*
Edward took up photography about three years ago and has already achieved a national salon acceptance and the Licentiateship and Associateship of the RPS. He likes to photograph people and hopes that his images capture the essence of the person. *(39)*

Bill Hall *(Northern Ireland)*
Photography has been a dominant factor in Bill's life for around 30 years. He is the secretary of Bridge Photo, the local camera club, where he makes good use of the darkroom facilities. He enjoys studio work, both portrait and still life, as well as landscapes. *(8)*

Kathleen Harcom *(Hampshire)*
Kathleen's main interest is landscape work, often using infrared film. She has successfully completed a number of courses in photography and has gained the Associateship of the RPS. *(144, 145)*

Dawn Heath *(Australia)*
Having graduated with an Associate Diploma of Art in applied photography, Dawn now works as a freelance. Her passion is for landscape work, where she uses infrared film to add mystery to her images. *(122)*

Andrew Hollingsworth *(Wiltshire)*
After dabbling in photography for 14 years, Andrew took an A-level course in 1995 at Swindon College. Not only did he gain an 'A' grade, but he now teaches darkroom technique on the same course on a part-time basis. *(12)*

Alfred Hoole *(Lancashire)*
Alfred has been interested in photography since he was 12, and in 1955 he joined Accrington CC (of which he is still a member). He is a regular participant in club, federation and national exhibitions. He takes particular pleasure in landscape and architectural work. *(4, 13)*

Graeme Hunter *(Tyne & Wear)*
A photography lecturer at Teesside Tertiary College, Graeme has a particular interest in experimental and 'old' processes, including hand-coated emulsions, transfers and lifts and pinhole images. *(100)*

Stephen Husbands *(Lanarkshire)*
In the last eight year years, Stephen has taken a more serious interest in his photography, using mainly infrared film for his landscape and pictorial work. Stephen enjoys photography not just for the enjoyment of the finished image but also for the pleasure of meeting people who inhabit the landscapes he shoots. *(54)*

Ken Huscroft *(West Midlands)*
Having been taking monochrome landscapes for many years, Ken is currently working on a 'trees in torment' series, most of which are accompanied by verse. *(57)*

Caroline Hyman *(Oxfordshire)*
Caroline trained as a photographer at the University of California and at the Ecole des Beaux Arts in Paris. As a freelance, she has worked for *US Vogue* and *US Cosmopolitan* and MGM Film Studios. She gained her ARPS in 1982 and Leica's Mirfield Award in 1996. *(26, 78)*

Steve Jackson *(Norfolk)*
Steve started photography in 1987 to take pictures of his children. He soon joined Hunstanton CC, where his interest in creative work blossomed. He is now working on combining traditional and digital photographic techniques to make monochrome images. *(41)*

Trevor Jackson *(Devon)*
Trevor's interest in photography was originally directed to colour slide work, but a City & Guilds course helped him discover the creative potential of monochrome. He is a member of the RPS, preparing work for distinctions. *(110)*

Edward Jones *(Motherwell)*
Edward describes himself as a "professional photographer having to do colour work for a living, but maintaining a passion for black and white". *(101)*

Robert Kent *(Staffordshire)*
Enthusiastic about photography since his mid-teens, Robert spent 12 years as a professional photographer before joining a professional processing laboratory 18 years ago, where he remains in a senior position. A passionate devotee of black and white, he is a founder member of the Moorland Monochrome Group. *(147, 148)*

Ian King *(Perthshire)*
Ian became hooked on photography at the age of 10, while watching a friend develop a print. He now sees the medium as a means of self-expression and enjoys the fact that we all see things differently, resulting in different printed interpretations of the same subject. *(49)*

Robert Kirchstein *(Berkshire)*
Robert has been interested in photography for 20 years and passionate about it for the last four. He is largely self-taught and tackles most subjects, although still life has become something of a speciality. *(76,125)*

Derek Langley *(Cambridgeshire)*
For the past five years, Derek has made a living from selling his monochrome prints at a craft fair in Cambridge. He specialises in moody winter scenes of mist and snow and in infrared photography. Derek has a book of his Cambridge landscapes under preparation for CM. *(152)*

Trevor Legate *(Sussex)*
An advertising and industrial photographer for over 20 years, he still enjoys the freedom of 'doing his own thing' and disappearing into the darkroom with black and white negatives to be surprised by what comes out. (106, 140)

Sérgio Leitão *(Portugal)*
Trained in still and video photography, Sergio works as a photographer and electronic news gathering reporter for the Portugese navy. He recently achieved the Licentiate distinction of the RPS with a series of portraits. *(126)*

Kay Mack *(Australia)*
An Associate of the APS and its Immediate Past President, Kay has recently retired and enjoys more time to devote to her photography and to travel. She teaches photography part-time at her local primary school. *(81)*

David Mahony *(Australia)*
David is the only photographer ever to win a gold, silver and bronze medal in a single Best of Friends Awards. His work has been exhibited and published around the world. He holds the Artist distinction of FIAP. *(37, 85, 111)*

Bob Marshall *(Buckinghamshire)*
Bob is a member of Amersham PS and has been hooked on photography since taking his first picture on a Brownie box camera 38 years ago. He works exclusively in monochrome and increasingly with landscapes. *(58)*

David Martin *(Hertfordshire)*
David has been interested in photography for about 12 years, developing a feel for monchrome work in the past couple of years. *(20)*

Maggie McCall *(Devon)*
Interested in photography for over 20 years, Maggie's favourite subjects are landscapes and portraiture. She gained her LRPS in 1996 and is currently compiling a panel for her Associateship. *(112)*

Dave Milano (West Midlands)
With just three years experience of photography, this is Dave's first piece of published work. Although black and white landscape is a particular favourite, his interests cover the whole spectrum of photographic subjects. (66)

David Miller (Tyne & Wear)
Dave says that his reward from working in monochrome comes from the simplifying effect it has on the subject, freeing him to concentrate on the light, form and texture of the image. (15, 16)

Reuven Milon (Israel)
Reuven's photographic work started in 1949, initially as a hobby and then as a profession. He has worked for the Israel Museum for many years. His personal preference is for monochrome work. (119)

Michael Milton (Devon)
A professional freelance, Michael spend much of his time recording the moods of the North Devon landscape, the subject of his CM book, *Exmoor and beyond*. A creative photographer with a distinctive printing style, Michael's work is represented in several picture libraries. (120, 121)

John Nasey (Jersey)
John was the gold medal winner in the first Best of Friends Awards. He is a Fellow of the RPS and has been entering national and international salons with considerable success since 1988. (133)

Donald Nesham (North Yorkshire)
Although photography has been an interest for Donald since the age of nine, it is only in the last seven years, since joining Northallerton CC, that he has taken it seriously. Donald is a great believer in basic photographic equipment and the Weston Master V. (1)

O Tudur Owen (Gwynedd)
Since retirement four years ago, Tudur's darkroom work has improved considerably. He is a member of two postal portfolios and of Club Camera Blaenau Ffestiniog (where most meetings are held in Welsh). Most of his photographs are taken in the Welsh mountains. (11)

Jeremy O'Keeffe (Kent)
The third generation of amateur photographers in his family, Jeremy's greatest photographic interests are buildings and outdoor views. A past member of several clubs, Jeremy has had both competition successes and exhibition acceptances. (98)

Roy Penhallurick (Shropshire)
Roy uses his photography to illustrate other interests – for example, his successful RPS Fellowship panel in 1992 was the result of a project to photograph and research traditional country crafts and skills. Roy is a PAGB lecturer and judge. (3)

Len Perkis (Norway)
Len's main subject interests are landscape, nature and travel. He has had his images widely published, including use as CM cards, and a major shipping line has used many of his landscapes to decorate its ships. (128)

Klaus Peters (Germany)
Klaus has been making photographs since 1967 and his work has been widely exhibited and published, including two books and four calendars. He holds the Artist distinction of FIAP. (86, 115)

Frank Phillips (Devon)
A chartered surveyor by profession, Frank's primary photographic interest is in landscape and coastal images. He is a member of Exmouth Photo Group and an Associate of the RPS. (89)

Gary Phillips (West Midlands)
Interested in photography since 1983, Gary built a darkroom at the bottom of his graden in 1990 and joined the Cannock PS. He now judges and gives talks to local camera clubs. (93)

Shirlie Phillips (Australia)
A keen photographer for the past five years, Shirlie enjoys all subjects, with a preference for photographing women and expanding her images to mixed media. She has been successful in national and international competitions. (31)

Brian Poe (Ross-shire)
An artist and teacher, Brian describes his purchase of a medium format camera as self-indulgent, but had the commitment to build a darkroom and teach himself some photographic craft. He describes his influences as abstract expressionism and surrealism, which he believes to be indicative of his vintage! (10, 67)

Dave Prodrick (East Sussex)
Dave describes himself as a serious photo junkie of three years' standing, with a preference for monochrome people pictures. His ambition is simply to continue taking pictures without becoming a camera bore: "I enjoy just getting 'the moment'; the rest is a means to an end". (38)

Patrick Rafferty (Scottish Borders)
Patrick began black and white photography at Tolcross Community Centre in Edinburgh in 1985. His influences include former Hawick CC member Warren Sanders, Les McLean and John Blakemore. (30)

Glen Ravenscroft (Australia)
Born in Manchester UK, Glen is a semi-pro who has lived in Australia for the last 25 years. Although he specialises in colour work, he loves the fine detail available in black and white work. He believes there should be more light-hearted fun in photography, using humour in his surrealist work, and claims to have a sexy bottom. (24)

Christopher Read *(Buckinghamshire)*
Christopher has concentrated on monochrome photography for the past three years, gaining inspiration and guidance from fellow members of Amersham PS. He enjoys the control that monochrome allows. *(87)*

Den Reader *(Norfolk)*
Den has held a number of solo exhibitions and his work has been included in numerous publications and is represented by a major picture library. This is the third consecutive occasion that his distinctive still life images have graced the pages of *Best of Friends*. *(25, 83)*

Malcolm Reed *(Cambridgeshire)*
A member of Leica Postal Portfolios, Malcolm has been a keen amateur for 35 years, working principally in monochrome. His current interest is in the small scale landscape, concentrating on texture, tone and form. *(129)*

Patrick Reilly *(Ireland)*
Patrick has been taking photographs since the 1970s. Whilst enjoying many aspects of the medium, he still finds monochrome the most satisfying: "while I think about my work, I don't feel the need to explain in detail: if other people like it, I see that as a bonus". *(114)*

Tom Richardson *(Lancashire)*
Tom has taken a serious interest in photography over the past 10 years, with the landscape as his preferred subject. His work has been accepted for numerous national exhibitions. He is an Associate of the RPS and the holder of a BPE distinction. *(69)*

Keith Rolleston *(Northern Ireland)*
Specialising in moncohrome photography, Keith is secretary of Bangor & North Down CC. He has a particular interest in still life and landscapes, particularly the details of derelict and abandoned homesteads in the rural areas of Northern Ireland. *(123)*

Malcolm Sales *(Nottinghamshire)*
An Associate of both the RPS and BIPP, Malcolm has been taking photographs since he was in the Scouts in the 1960s. His interest became more serious as he became increasingly involved in mountaineering expeditions, working mainly in colour. *(94)*

Margaret Salisbury *(Denbighshire)*
Margaret is the current (and first lady) chairman of the London Salon of Photography. Among her lengthy list of achievements are the Fellowship of the RPS, the Artist of Excellence of FIAP and an award of the PAGB for her contribution to club photography. *(82)*

Hazel Sanderson *(West Yorkshire)*
Using her keen appreciation of lighting, texture, tone and composition, Hazel has the exceptional ability to make a memorable image from a mundane subject. She is also the author of CM's book, *Dales of Yorkshire*. *(18, 19, 131)*

Cameron Shaw *(Nottinghamshire)*
Cameron's lifelong interest in photography has only recently found expression in monochrome. His work has been shown in exhibitions at home and abroad, gaining awards and distinctions. He holds the LRPS. *(142)*

Brian Skinner *(Surrey)*
Although interested in photography since the early 1950s, Brian says he has learned more about photography in the last six years than in the previous 40. He attributes this to joining Woking PS and building a new darkroom. *(118)*

Roger Skinner *(Australia)*
Roger suffers under the illusion that an 8-page CV listing countless awards, exhibitions, publications, commissions and collections constitutes a brief personal profile for *Best of Friends*. *(116, 149)*

Mark Snowdon *(North Yorkshire)*
Mark developed his interest in photography in 1986 whilst living in South Africa. He works almost entirely in monochrome. He gained his Associateship of the RPS in 1991 and is working towards the Fellowship. *(68, 91)*

Bob Stevenson *(Surrey)*
Bob recalls using his father's Box Brownie in 1938. Since early retirement in 1986, his hobby has become an addiction. He has recently focused his attention on pictorial work and, although he says he has not achieved any real success, he continues to travel hopefully. *(80)*

Boon Kiat Tan *(Singapore)*
No profile available. *(5)*

Steve Terry *(Isle of Skye)*
Steve and his wife have recently opened a photographic holiday centre on the Isle of Skye, where he hopes to find more time for monochrome landscape work. He is an Associate of the RPS. *(9)*

Peter Thoday *(Lincolnshire)*
Peter says he likes nothing better than to be alone in the landscape without a hiker or anorak in sight, but apart from that (and hours in the darkroom), he says he is quite sociable. His favourite locations so far are Lindisfarne and the Northumbrian coast. *(108)*

Cliff Threadgold *(New Zealand)*
Now based in Wellington, Cliff continues to be very active in his photography. An Associate of the RPS and member of Wellington PS, Cliff is currently preparing a panel for the Associateship of the PSNZ. *(74, 127)*

Mike Tinsley *(Kent)*
Mike has concentrated on monochrome photography since returning to the UK from the South Pacific in 1989. He uses a variety formats from 10x8 field outfits down to "toy" 120 cameras. He has spent a lot of time recently exploring the 'alternative' processes. *(21)*

Daniel Toeg *(London)*
A part-time photography student at Camden's Kingsway College, Daniel has recently developed an interest in image derivation, such as outline and drop-tone printing, and the older monochromatic photographic processes, such as cyanotype and kallitype. *(43, 45)*

Nenne van Dijk *(London)*
During a distinguished career in sculpture, Nenne used photography to record her work and for publicity purposes. This stimulated an interest in photography as an alternative art form, where her work includes pictorial subjects, the natural world and portraits. *(28)*

Paul Webster *(Cheshire)*
Paul says that he would much rather be out taking photographs ("which is what it is all about") than writing about them or himself. *(6, 63, 71)*

Jean Wheeler *(Hampshire)*
Jean has been producing black and white photographs for about 10 years. She exhibits with a small group, Image workshop, which pushes her into producing new work on a regular basis. *(130)*

Jim Wild *(Gwent)*
Jim became a professional photographer in the 1980s, gaining his ARPS in 1985. He is currently a photographer with the National Museums and Galleries of Wales. He still uses monochrome as the most creative and expressive medium for his personal work. *(44, 92)*

David Wilding *(Gwent)*
Baptised into photography at the age of 12 with the gift of a Box Brownie, David still waxes lyrical about the darkroom – "a magical space where safelight, paper and chemicals come together and pictures are born into the world". We get the impression he enjoys his photography! *(102, 104)*

Peter Williams *(West Midlands)*
Peter first came to photography through the desire to record his fish catches. He now has his own darkroom and enjoys printing subjects ranging from motorcycle racing to natural history and landscapes. He is currently building a 5x4 camera and enlarger. (52, 99)

Geoff Young *(London)*
Geoff is a professional photographer specialising in the performing arts, using both home and touring studios. He enjoys the creative challenge of exploring the talents and beauty of each new subject. *(34)*

Karen Zalokoski *(Bristol)*
Karen began a serious interest in photography in 1988 when joining Hanham PS, quickly developing a preference for monochrome work. She gained her ARPS in 1994. She makes mainly landscape and abstract images, but following the arrival of her daughter Katrina, Karen is increasingly interested in portraiture. *(50)*

GLOSSARY OF ABBREVIATIONS USED IN PROFILES

APS Australian Photographic Society

BIPP British Institute of Professional Photography

BPE British Photographic Exhibitor – 'crown' awards based on acceptances in recognised national salons

CC Camera club

FIAP (translated as) International Federation of Photographic Art: awards distinctions, including Artist, Excellence and Master, based mainly on acceptances and awards in recognised international salons.

PAGB Photographic Alliance of Great Britain

PS Photographic Society

PSA Photographic Society of America

PSNZ Photographic Society of New Zealand

RPS The Royal Photographic Society (UK); awards distinctions at Licentiateship (LRPS), Associate (ARPS) and Fellowship (FRPS) levels, mainly by assessed submissions of work.

UPP United Photographic Postfolios

CREATIVE MONOCHROME
For further information on the Friends of Creative Monochrome, Creative Monochrome's range of books and our magazines, *Photo Art International* and *Mono*, please contact:

Creative Monochrome Ltd
20 St Peters Road, Croydon,
Surrey, CR0 1HD, England
Tel: 0181 686 3282 (int: ++ 44 181 686 3282)
Fax: 0181 681 0662 (int: ++ 44 181 681 0662)
e-mail: roger@cremono.demon.co.uk